PASTEL PAINTING TECHNIQUES

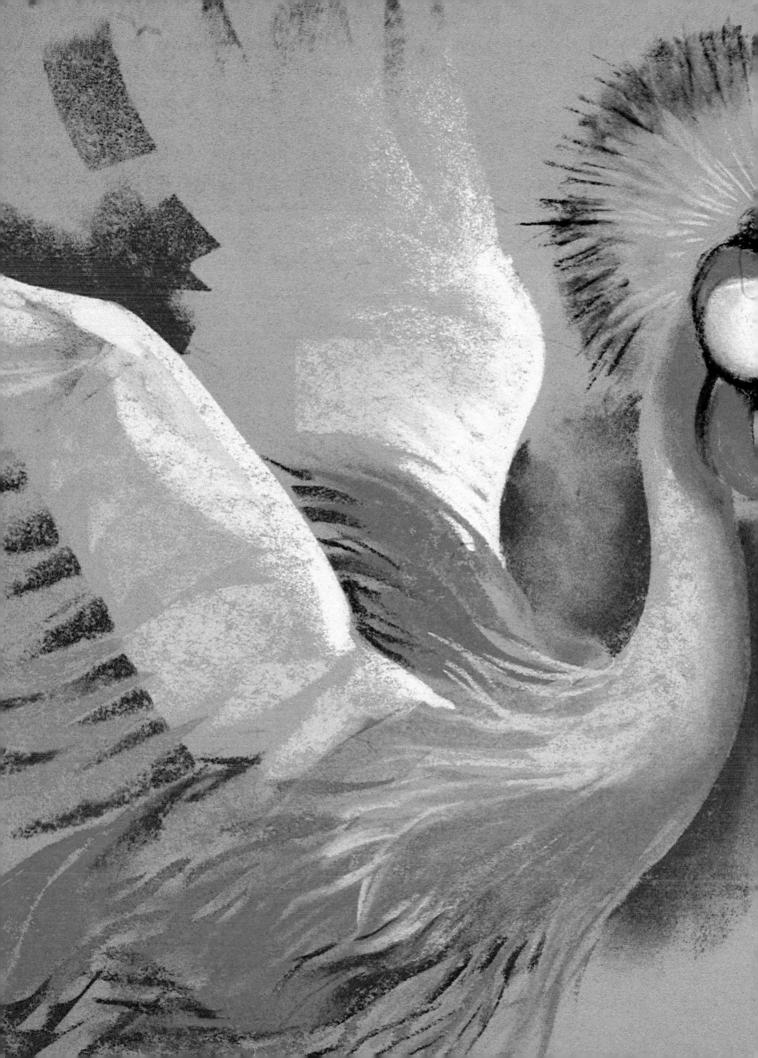

PASTEL PAINTING TECHNIQUES

17 pastel projects, illustrated step by step with advice on materials and techniques

Guy Roddon

Contributing Editor Angela Gair

A Quarto Book

Copyright © 1987 Quarto Publishing Plc First published in North America by North Light Books, an imprint of F&W Publications 1507 Dana Avenue Cincinnati, Ohio 45207

First paperback edition, 1991

Reprinted 1992, 1996, 1997, 1998

ISBN 0-89134-396-2

All rights reserved

No part of this publication may be reproduced, in any form or by any means without permission from the Publisher.

This book was designed and produced by Quarto Publishing Plc The Old Brewery, 6 Blundell Street, London N7 9BH

> Senior Editor Sandy Shepherd Art Editor Marnie Searchwell

Contributing Editor Angela Gair Editor Hazel Harrison

Designer Hazel Edington Design Assistant Ursula Dawson

Photographers Ian Howes and John Wyand Paul Forrester

Paste-up Mick Hill, Patrizio Semproni

Art Director Alastair Campbell Editorial Director Carolyn King

Typeset by Central Southern Typesetters, Eastbourne Manufactured in Hong Kong by Regent Publishing Services Ltd Printed in China

The publishers would like to thank Conté (UK) Ltd for supplying materials and equipment

	1	`	
		ONTENT	S
			<u> </u>
	1	THE PLEASURE OF PASTELS	7
~3	2	EVERYTHING YOU'LL NEED	17
	3	PASTEL TECHNIQUES	33
	$\overline{4}$	USING MIXED MEDIA	107
	$\frac{\frac{2}{3}}{\frac{4}{5}}$	COMPOSING THE PICTURE	117
	6	WORKING WITH COLOR	123
	7	MATS AND FRAMES	137
		GLOSSARY	142
		INDEX	143

The Pleasure of Pastels

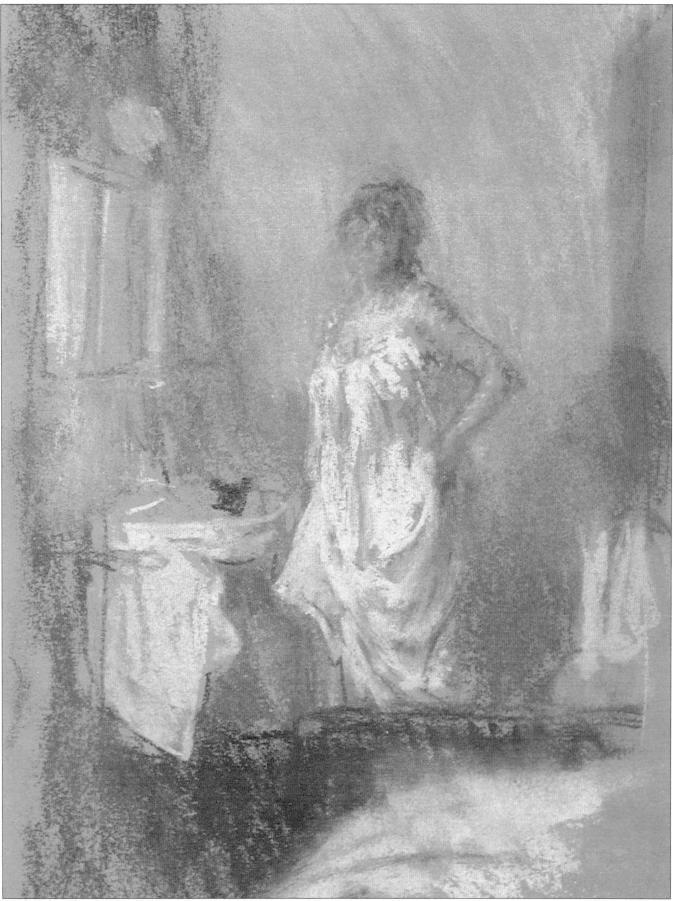

CHAPTER ONE

THE PLEASURE OF PASTELS

There must be few artists who have not wanted to try their hand at painting with pastels at some time or other – but why? What is the appeal of this increasingly popular medium?

Perhaps one reason is the beauty of the pastels themselves. Unlike paints, which hide their colors in metal tubes, pastels are not shy about displaying their charms. When you open up a fresh box of pastels, your eyes are met by a riot of sumptuous color so that you can hardly wait to begin painting. The allure of pastels not only tempts the eye, it beckons to the hand as well; there is something very attractive about the feel of the pastel stick in one's hands. Unlike paints, but like all drawing media, pastels offer the satisfaction of immediate contact with the paper; the crayon is so easy to manipulate that it feels almost like an extension of your fingers. Perhaps this sense of immediacy touches a deeper instinct, a far older and more primitive urge to create meaningful and lasting marks for others to see. It is the same impulse demonstrated by children when they pick up a piece of chalk to draw on a wall or pavement.

> This pastel, *Interior, Venice*, by Bernard Dunstan, is rather reminiscent of Edgar Degas, the master of the medium. Pastels are wonderfully versatile to work with. Easy to manipulate, they can assume the richness of a painting while still retaining the freshness and vitality of a sketch.

Because pastel is such a rapid and responsive medium, it is ideal for recording the fleeting, transitory effects so often found in nature. Melting mists, scudding clouds, crashing waves – all these can be captured with a few rapid, decisive strokes. There are no colors to be pre-mixed, no drying times to worry about, no brushes to be kept clean – in short, no tiresome procedures to dampen your enthusiasm or dull your response to the subject.

The unique quality of pastels is their versatility; they can be used as both a drawing and a painting medium. Simply by twisting and turning the crayon, using the tip and then the side, you can create several different effects – fine, precise lines; broad, sweeping strokes, and solid, dense layers of color – and these can be combined in an almost infinite number of ways. Thus pastel is equally appropriate for highly finished, complex studies and for rapid impressions.

The colors are not only immensely varied, from soft, delicate tints to bright, vibrant hues and rich, deep darks, they are also extremely pure and luminous, due in part to the way in which light reflects off the myriad particles on the surface of the painting. Furthermore, pastel colors remain fresh and lively from the start, and do not change color when applied, unlike watercolor, for example, which appears much paler when dry, or oil paints which sink into the canvas, and can darken or even crack with age.

On the purely practical level, pastels are simple and convenient to use. You don't need much in the way of extra equipment such as brushes, knives and mixing mediums, and no preparation of the painting surface is necessary, as it is for oil and watercolor. Just lay out your pastels and you're ready to start, and when you're finished, all you need to do is put away your pastels – there are no brushes to clean, no palette to scrape and no need to cover up the pigments to stop them drying out.

Of course, pastel does have its drawbacks, too – what medium doesn't? One of the great masters of pastel painting, Quentin de La Tour (1704–88) once wrote to a friend: "Pastels, my Lord Marquis, involve a number of further obstacles such as dust, the weakness of some pigments, the fact that the tone is never correct, and that one must blend one's colors

on the paper itself and apply a number of strokes with different crayons instead of one, that there is a risk of spoiling the work done and that one has no expedient if its spirit is lost." So if you do encounter difficulties with the medium, take heart – you're in good company!

The most obvious drawback of pastel is its fragility. The sticks sometimes crumble and break under pressure, and a pastel painting is vulnerable to accidental smudging and smearing if it is not mounted under glass or protected with fixative.

Also, though pastels are easier to handle and more immediate in use than oil paints are, it has to be admitted that they are less flexible. For example, you can't mix pigments on the palette to achieve just the right color or tone – you must work with a preexisting range of tints, creating special color effects directly on the paper. Similarly, mistakes are easily rectified in oils and to some extent acrylics, by wiping out with a rag or simply overpainting the offending area, but in pastel they require more careful treatment because the surface can easily become clogged, smeared or damaged.

Finally, because pastel is both a drawing and a painting medium, the ability of the artist to draw confidently and well is more important than in some other media. Weak drawing can, to a certain extent, be masked in oil painting; but in pastel the marks made by the artist's hand remain visible and unchanging, so you have to get them right first time.

Pastels, like children and animals, are very appealing but sometimes difficult to control. In this book I hope to offer you a deeper understanding of the nature of pastels, so that you can overcome the difficulties and enjoy the many pleasures offered by this unique and versatile medium.

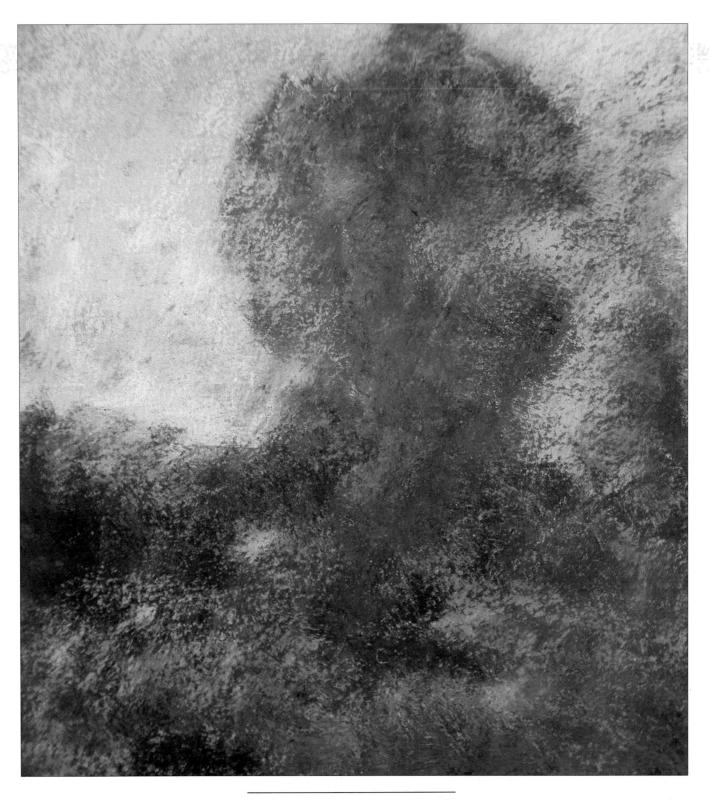

Pastels are ideal for capturing the fleeting effects of nature, and are well suited to outdoor work as there are no preparations to worry about. In this striking landscape study, the artist, Nick Swingler, has scumbled his colors over one another and made much use of the rough texture of the paper to give an impression of shimmering light and color.

The Pleasure of Pastels

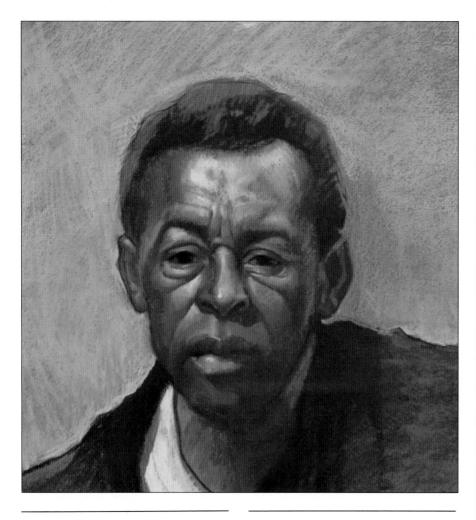

In the pastel *above*, *Waiting at Eastern Market* by Deborah Leber P.S.A., the artist has worked on sandpaper to build up thickly impastoed color ranging from pale blue, mauves and pinky browns to deep purples and near blacks. The somber colors are entirely in keeping with the image, creating a feeling of sadness and introspection. This charming, light-filled picture by Charlotte Ardizzone *right* presents a striking contrast to the dark, brooding portrait. Here all the colors are light and delicate, and the mood lively and cheerful. The two pictures together give a clear idea of the very different effects that can be created with this vérsatile medium.

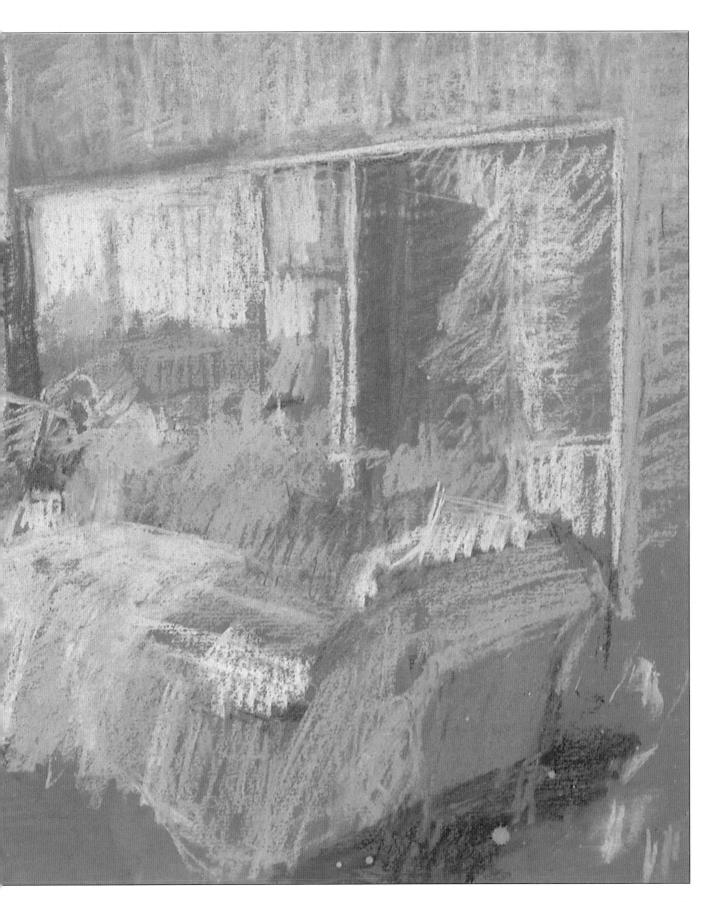

The Pleasure of Pastels

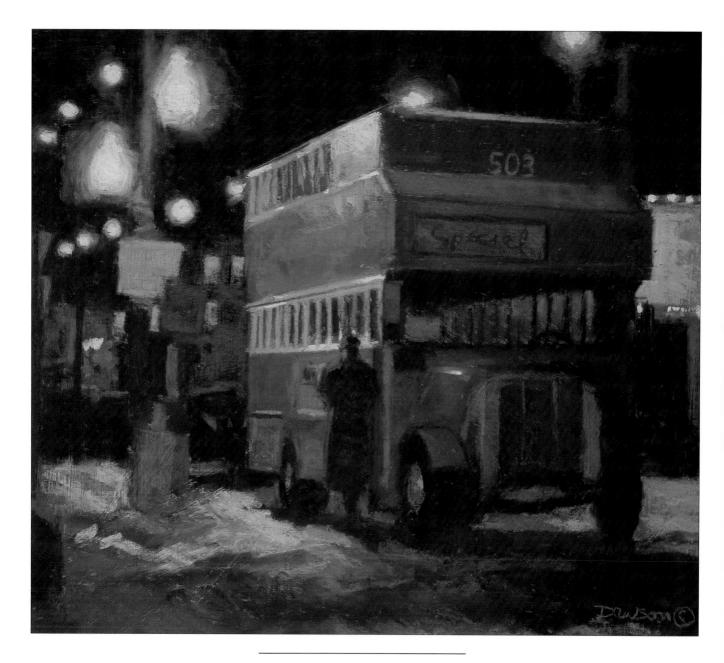

This artist, Doug Dawson, has experimented with other media in the past, but now works almost exclusively in pastel, which he finds the most satisfying and expressive. In *503 Special* he has created unity and harmony by using relatively few colors and repeating them; green and gold, for instance, recur in varying amounts throughout the picture.

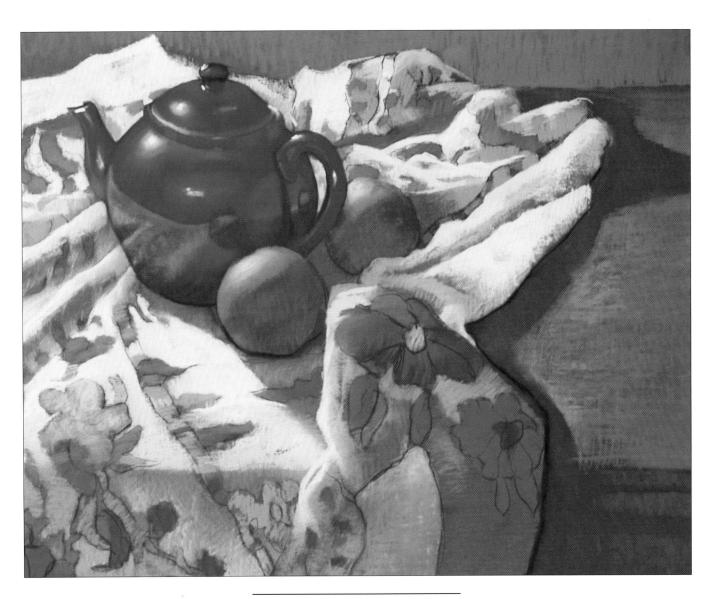

Any lingering impression that pastel is a fragile medium best suited to tentative sketches by "little old ladies" is quickly dispelled by this vibrant still life by Deborah Leber P.S.A., *The Blue Teapot*. This artist likes to work on rough surfaces, which enable her to build up dense, saturated colors that look almost like oil paint.

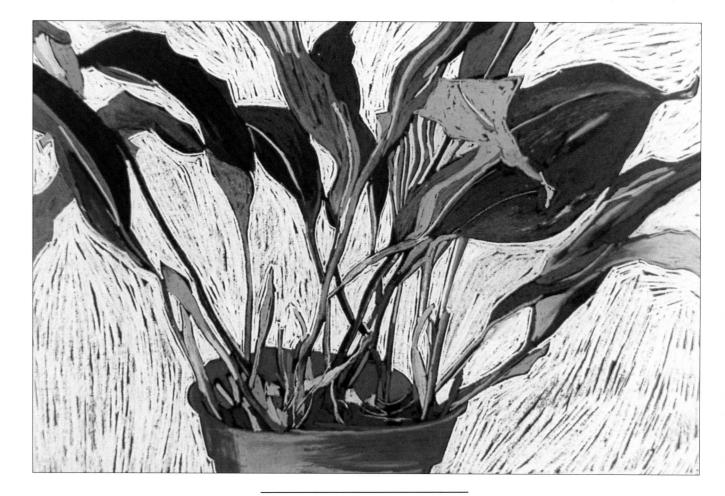

In this plant study, *Aspidistra* by Frances Treanor, the pastel has been used in a bold and directional way to describe the sinuous forms of the leaves and stems. The tonal contrasts are strong and the forms "hard-edged," with none of the soft, hazy look usually associated with pastels. Notice how the light tones of the background have been applied with sweeping strokes, leaving lines of the darker paper showing through so that they echo the shapes of the plant itself.

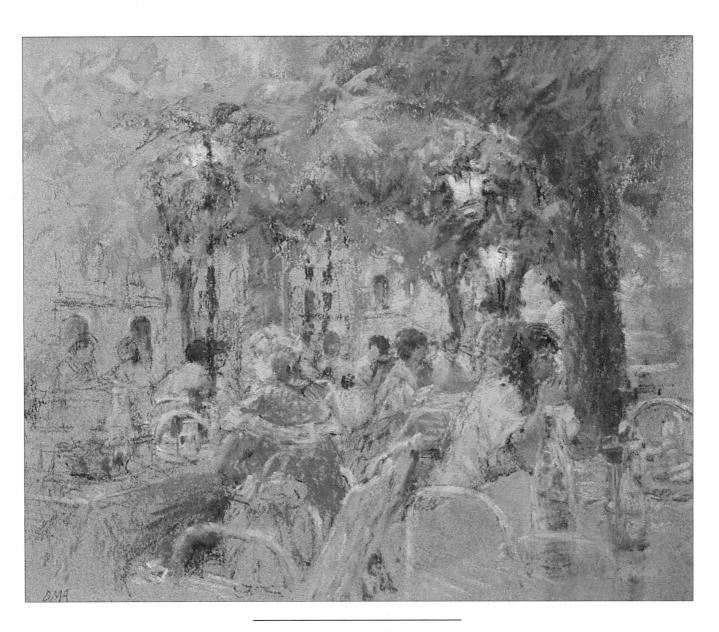

This painting, *Café at Villefranche-le-Conflent*, by Diana Armfield, is in a more obviously pastel style than the example opposite. Here the artist has conveyed the effects of light and sunshine by using the pastels very freely, allowing some of the original drawing lines and areas of the paper to show through in places. The picture gives a strong impression of light and life, and conveys the feeling of relaxation associated with an outdoor café on a fine day.

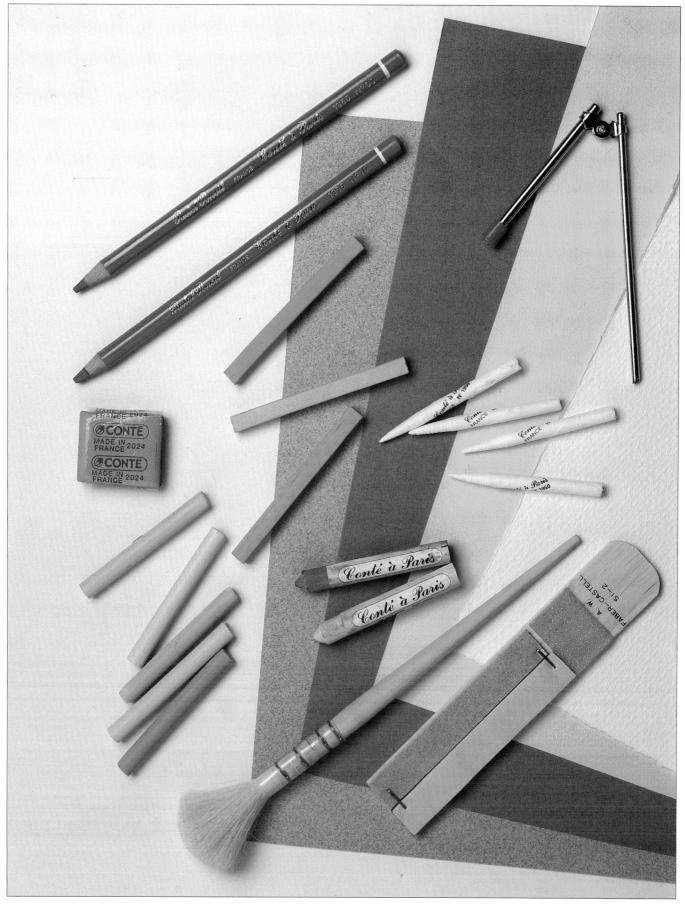

CHAPTER TWO

EVERYTHING YOU'LL NEED

One of the great advantages of pastel painting is that you don't need a great deal in the way of extra equipment — no mixing mediums, brushes, palette knives or unwieldy canvases — just the pastels themselves and a selection of papers. However, you will need to have some idea of which colors to buy, as good pastels are not cheap, and you'll need a much wider range than you would for paints. You'll also need to know which pastels — hard ones or soft ones — can give the particular effects you're after, and which surfaces to choose — the color and texture of the paper can be a very important part of a pastel painting.

In this chapter I provide guidelines on all these topics as well as explaining the uses of the different types of fixative and of various handy extras for blending and erasing. Most important of all, I tell you how to familiarize yourself with your pastels, how to care for them, and how to save money by making your own, which is a good deal easier than it sounds.

All about Pastels

Pastels are made from finely ground pigments bound together with a small quantity of gum to form a stiff paste, which is then shaped into round or square sticks and allowed to harden. The word "pastel," in fact, is derived from the Italian word *pastello*, which means paste.

There are four main types of pastel available soft and hard pastels, pastel pencils and oil pastels. The softness or hardness of a pastel stick is determined by the amount of binder used, the hardness of the pigment and the degree of pressure applied during the shaping of the sticks. Soft pastels contain just enough binder to keep them in stick form and are combined with white chalk, clay or gypsum to increase their covering power. It is this white filler that is responsible for the delicacy of hue associated with soft pastels, particularly noticeable in the flesh tints. Hard pastels contain more of the gum binder, which makes them stronger, and they're mixed with black pigment instead of chalk — which is why they tend to comprise the darker colors available.

Because of their different consistencies, soft and hard pastels each produce a different range of textures and effects, and the two types can be combined quite happily in the same painting.

SOFT PASTELS

HARDPASTELS

SOFT PASTELS

Soft pastels are the most widely used of the various pastel types, because they produce the wonderful velvety bloom that is so typical of the medium. The reason for this is that soft pastels contain very little binder or hardening agent, but proportionately more pigment; when you use them, you'll notice how rich and vibrant their colors are and how smoothly the pastel stick glides across the surface of the paper.

Although hard pastels may be used in the initial stages, most people use soft pastels for the bulk of their painting, because they are easy to blend and smudge, and their thick, velvety quality is ideal for creating rich, painterly effects and for covering large areas quickly.

The only disadvantage of soft pastels is their fragility. Because they contain so little binding agent they are apt to crumble and break easily, and are more prone to smudging. But this is not a major problem, and you'll soon develop the right sensitivity of touch if you use soft pastels often enough.

Since the degree of softness varies noticeably from one brand of pastel to another, I'd advise you to try out individual sticks from different manufacturers until you find the one that suits you best and only then buy a full range of your choice. The good makes include Conté, Sennelier and Rembrandt pastels.

HARD PASTELS

Hard pastels contain more binder than the soft type, and because of their firm consistency they are generally used in a drawing rather than a painting capacity. Unlike soft pastels, hard pastels can be sharpened to a point with a razor blade and used for making crisp lines and precise strokes. Alternatively, you can snap them in half – because they are rectangular rather than round in shape, each of the four corners makes a clean, sharp point for drawing.

Whereas soft pastels are used for broad effects, hard pastels are used mainly in the preliminary stages of the painting or to add fine details and accents in the final stages. I always start by defining the composition in hard pastel because it doesn't crumble and clog the tooth, or textured surface, of the paper (if the tooth of the paper is filled up too early, the surface becomes slippery and the subsequent layers of color will not adhere properly). In addition, hard pastel is easy to erase during the initial stages, by gently stroking the area with a hog bristle brush or a rag; this allows any corrections or adjustments to be made to the composition before the working-over stage, when it would be too late.

PASTEL PENCILS

PASTEL PENCLS

Thin pastel sticks are available encased in wood, just like normal pencils. They're more expensive to buy, but I always have a few on hand because they're ideal for subjects that entail intricate work. Pastel pencils can be sharpened to a point, using sandpaper or a craft knife to produce extremely fine, crisp lines. Because of their length and their resistance to snapping or crumbling, pastel pencils give you greater control of handling and are excellent for techniques such as cross-hatching and feathering. Another advantage, of course, is that your fingers stay clean!

OIL PASTELS

Oil pastels are made by combining raw pigments with an oil binder instead of gum, and this makes them somewhat different in character from traditional pastels. Whereas traditional pastels are known for their soft, velvety texture and subtle color, oil pastels make thick, buttery strokes and their colors are deeper and more luminous – more akin to oil paints, in fact.

Because they are encased in an oil substance, oil pastels are less crumbly than soft pastels are, so they are less likely to smear and break. This makes them convenient for use outdoors, and an added bonus is that they need little or no fixing.

Oil pastels should always be used by themselves, not in combination with pure pastels, because their characters are so different. On the whole, oil pastels are a more robust medium so they are best suited to a direct, spontaneous way of working. They are also great for experimental and mixed media work. The crayons can be dipped in turpentine or mineral spirit and applied "wet," or you can soften and blend the colors on the paper with a soft brush dipped in the medium (see chapter 4). In addition, the waxy surface can be scratched into with a sharp tool to create lively patterns and textures – a technique known as sgraffito.

CHOOSING YOUR COLORS

In oil and watercolor painting you need only a dozen or so pigment colors on your palette, from which you can mix a vast range of hues, tints and shades. With pastels you cannot mix new colors as you work; almost every color, and every tint or shade of that color, requires a separate pastel stick. This explains why there are literally dozens of different colors available in pastels, and each separate color comes in a range of up to eight shades, from light to dark.

From this bewildering array of colors, how do you

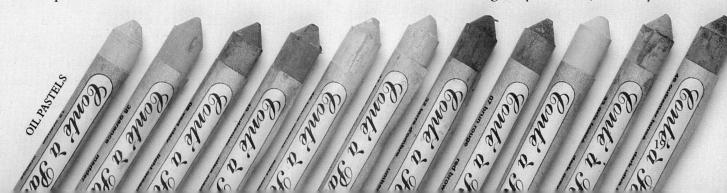

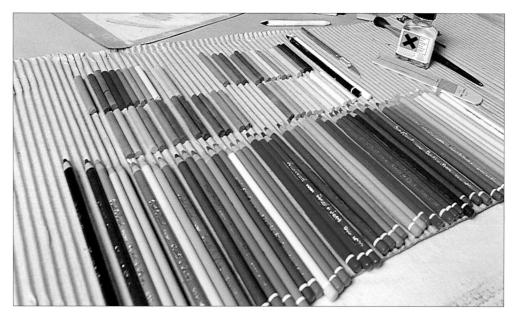

A useful way of organizing your materials *left* is to range both pencils and pastels into warm and cool versions of each of the most important colors of the spectrum.

Pastels have a tendency to roll off the table, crumble or break, so by sticking the colors you need into a layer of rice *right*, you can avoid losing them or getting them dusty.

choose a manageable quantity to suit your needs, without incurring too much expense? My advice is to start by thinking about what sort of subjects you like to paint, and choose your palette of colors accordingly. If your subject is landscapes, obviously you'll need a lot of greens and earth colors; for portraits, a range of flesh tones plus a few extra colors for the sitters' clothing; and if you're a flower painter, you can really go to town on bright, vibrant colors. Even so, you will always need a selection of neutral colors for the shadows and highlights, such as a range of grays and buffs.

whing You'll Need

Another approach would be to select a warm and cool version of each of the most important colors in the spectrum: I've listed some suggestions below, but remember they are only suggestions and you may have personal preferences of your own.

	WARM	COOL
Red	vermilion	alizarin
Blue	ultramarine	cobalt
Yellow	cadmium yellow deep	lemon yellow
Green	chromium oxide green	viridian
Brown	burnt umber	raw umber

Add to these black, white and a few "workhorse" colors such as yellow ocher, burnt sienna and caput mortuum, and you'll have a good basic range to start with. But don't forget, whichever colors you select you will need at least three shades of each color (a

light, middle and dark tone). So if you choose a palette of 20 colors you will in fact need 40 to 60 sticks of color. Some dedicated pastellists have literally hundreds of pastel sticks at their disposal!

It might be an idea also to buy a few hard pastels, for the preliminary and final stages of a painting. Hard pastels come in only one shade of each color, and the range of colors itself is more restricted than that of soft pastels, so at least the task of selection is made easier.

Some books recommend starting out with one of the boxed sets of pastels that manufacturers produce. These come in many sizes, from a simple set of 12 colors to a de-luxe set of 300, and you can even buy pre-selected assortments specially for the "landscape painter" or the "portrait painter." But be warned – while there's nothing more seductive than a neat box of pastels with gorgeous, jewellike colors and romantic names like "mouse gray" and "pansy violet," many of these colors could turn out to be superfluous to your needs. It's better by far to choose a good range of basic colors and add one or two of the more exotic ones as you need them.

HOW PASTELS ARE GRADED

Every pastel manufacturer produces a range of fullstrength colors (pure pigment to which no white or black is added). In addition, every pure color has a range of light and dark tones, made by adding care-

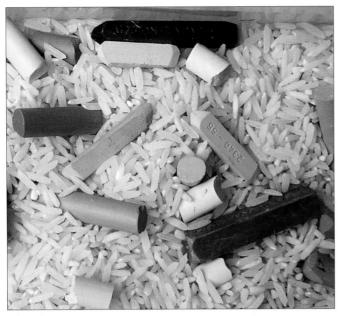

fully graded percentages of white or black pigment to the pure, full-strength color. The tonal range of each color is indicated by a system of numbering which corresponds to the various strengths of each color. So, for example, you may find that burnt umber has No. 1 against its lightest shade, and No. 8 against its darkest. Annoyingly, though, the numbering system is not standardized from one manufacturer to another; the firm of Talens, for example, who makes the Rembrandt range of pastels, uses a series of decimal points to denote the proportion of white filler added to the color. So, if 60 is the number for ultramarine, the pure tint is 60.5, with no white or black added; 60.9 is the palest tint, having 80 percent white added to it; while 60.2, with 60 percent black added to it, makes a dark blue which is nearly black.

TINT CHARTS AND NUMBERING

A useful and effective way to get to know your pastel colors is to make a tint chart. This is simply a sheet of paper on which you can keep a visual record of all your pastel colors. The paper labels on pastel sticks do tend to come off or disintegrate in use, and when this happens you have no way of knowing the name or the exact tint number of the color, which is a nuisance when you come to replace those pastels that have worn down.

As soon as you buy a new pastel color, fill in a

square of that color on the chart and then enter beside it its name and number. This way, when you come to restock your colors you will know exactly which ones to buy.

If you make your own pastels, a tint chart is also a handy way to record the exact quantities of each pigment used to make a particular color. For instance, if you have made a stick with 60 percent ultramarine and 40 percent white, and find the color to your liking, make a record of these quantities on a tint chart so you can use the same formula again next time.

LOOKING AFTER YOUR PASTELS

Pastels have an advantage over other media in that they're convenient to use – there's no need for brushes, knives, rags or jars of water or turpentine, as with oils or watercolors. But pastels have disadvantages, too. As already mentioned, you may need to use 20 or more pastels during the course of a painting, and keeping control of them requires a degree of self-discipline. Unlike paints, which stay obediently in their place on the palette, pastels seem to have a will of their own; they roll off the table and break on the floor, they lose their paper covers and acquire a film of gray dust instead, and certain colors have a knack of disappearing altogether, just when inspiration strikes you.

To avoid mistakes, muddy colors and frayed tempers, it's important to devise a systematic method of laying out your pastels during the course of the painting, and of storing them afterward. It's a good idea to arrange your pastels in the grooves of a length of corrugated cardboard pinned to a flat board, to prevent them from rolling off the table. I arrange mine in columns according to color, and with each color lined up from light to dark, and I also make sure that each pastel is replaced in the correct groove after I've used it.

Of course, not everyone likes to work in a methodical way. I know of some artists who prefer to simply scatter their pastels in a heap on the table. It's basically a matter of temperament, and no doubt you will devise your own system in time.

Making Your Own Pastels

Pastel sticks are available in just about every hue, tint and shade you can imagine, but even so there are several reasons why making your own pastels can be a good idea. First of all, it's a simple process probably easier than baking bread! Second, the colors of homemade pastels are often brighter and richer than those on offer from art supply stores, which may contain fillers and extenders. Third, you can mix your pigments to achieve exactly the shade and consistency you want. Fourth, you can save yourself a lot of money. As you have probably found out already, pastels are fairly expensive to buy and soft pastels in particular seem to wear down quickly: homemade pastels cost a fraction of the price of the store-bought variety. And finally, making your own pastels is a fascinating way to learn about mixing colors.

THE INGREDIENTS

The basic ingredients for pastel-making are readily available from any good art-supply store. These are: powdered gum tragacanth, precipitated chalk (calcium carbonate), distilled water, beta naphthol (a preservative) and dry pigments. You'll also need bowls and palette knives for mixing, a glass or marble slab, some jars with airtight lids and plenty of paper towels.

MIXING THE COLORS

Begin by making the binding solution which will hold the color pigments together. In a large bowl, mix 4 tablespoons of powdered gum tragacanth and 1/2 teaspoon of beta naphthol with 2 pints of distilled water, and let it stand overnight in a warm place. To save time, the binding solution can be made in large

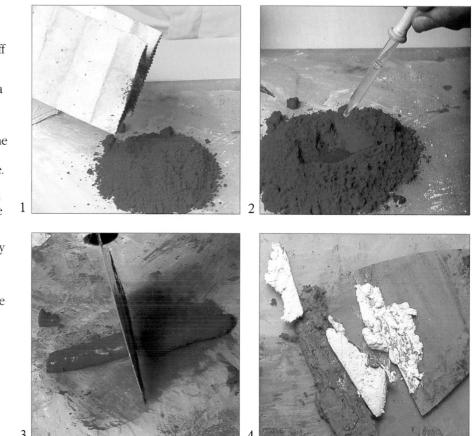

1 Here pure powdered pigment is poured onto the glass, and enough binding solution is added to make a stiff paste.

2 The paste is mixed thoroughly with a palette knife until all streaks of color disappear.

3 To make a tint (a lighter version of the pure color), start by dividing the paste into two equal parts with a palette knife.

4 Into one half, mix some precipitated chalk which has been made into a paste with the binding solution.

5 The two pastes are mixed thoroughly until the original color lightens.

6 A whole field of new colors can be created by mixing different colors at the paste stage. Here, red and white are added to the pure color to give a gray tone.

quantities and stored in airtight jars. So long as you add the beta naphthol to the mixture, it will keep indefinitely. To make soft pastels, add more distilled water to the binding solution; for hard pastels, add more gum tragacanth.

To make pure color pastels, pour the dry powdered pigment onto the glass or marble slab, add enough of the binding solution to make a very stiff paste, and mix thoroughly with a palette knife until all the streaks of color disappear. Every pigment reacts differently – the earth colors, for example, contain more clay – so judging the proportion of powder to solution will be a matter of trial and error at first.

As well as pure colors, you can also mix an infinite variety of tints and shades of each color. To make a tint (a lighter version of the pure color) start by mixing the binding solution with precipitated chalk to make a white paste. Then take an equal amount of the pure color paste and mix the two thoroughly. Although it might seem easier to mix the precipitated chalk with the dry powder pigment, for some reason the colors combine better at the paste stage.

To make a shade (a darker version of the pure color) follow exactly the same procedure as above, but use ivory black pigment instead of precipitated chalk.

MAKING THE STICKS

When the paste is thoroughly mixed and there are no streaks of color, it is ready to be shaped into sticks. Start by kneading the paste on a glass or marble slab covered in paper towels to remove any surplus moisture and air bubbles. Pinch off small lumps of paste and roll them into sticks on the paper towels; do this by laying your forefinger along the length of the stick, not at right-angles to it. Alternatively, you can make a smoother stick by rolling the paste with a small piece of cardboard covered in paper towel.

Set the pastel sticks aside on some newspaper and allow them to dry at room temperature for 48 hours.

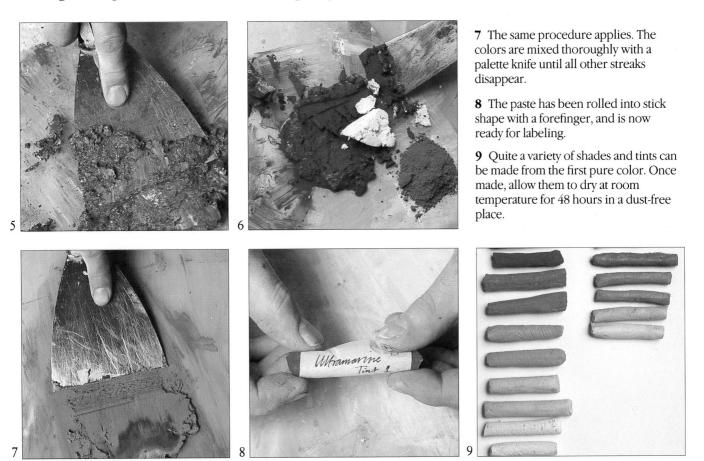

Choosing a Surface

A pastel painting is very much a marriage of pastel and paper. The two work side by side, creating an exciting fusion of texture and color that is unmatched in any other medium. In this chapter I'll be discussing the various pastel surfaces that are available and their relative pros and cons. But whatever surface you choose to work on, there are three factors that should always be borne in mind when making that choice. These are: *tooth* (how rough or smooth the paper's surface is); *tone* (how light or dark the paper is); and *color* (whether warm, cool or neutral).

verything You'll Need

TOOTH

Whereas an aqueous medium works by actually sinking into the surface of the paper and staining it, pastel more or less sits on the surface. If that surface were as smooth as glass, the pastel pigment would soon start to flake off, since it would have nothing to adhere to. That's why, if you examine a sheet of pastel paper under a strong light, you will see that its surface is pitted rather than smooth. The expression "tooth," refers to these tiny ridges and hollows in the surface, whose purpose is to "bite" the particles of pastel as the crayon is stroked across the paper and then hold them in place.

Rough papers have more tooth than smooth papers do, and the kind you choose depends on the techniques you want to use and the effect you want to obtain. Both types, however, must contain size, should be fairly thick and of a good quality.

Rough papers are a must if you intend working in a bold, vigorous style with thick layers of color. The deeper hollows in rough paper are capable of holding more pigment, so you can superimpose layers of color one on top of the other. To test whether the tooth is filling up too much, tap the back of your board; if the pastel is flaking off slightly, give the painting a light spray of fixative before applying further layers.

When pastel strokes are applied lightly to rough paper, they take on a soft, grainy quality because the pigment is caught on the ridges but not in the grooves. This creates a sparkling, broken-color effect which is very expressive. In addition, the grainy texture of the paper itself can add much to the overall visual effect of the painting.

Smooth papers have less tooth than rough papers do, so the pastel pigment lies more smoothly and evenly on the surface. Because the hollows in the surface are so shallow, they quickly fill up with pastel particles. The finer the tooth, the fewer layers of pastel the surface can hold, so you can't build up thick layers of color as you can with rough paper. Smooth-textured papers are best suited to fine details and linear work, although soft blending also works well on a smooth surface.

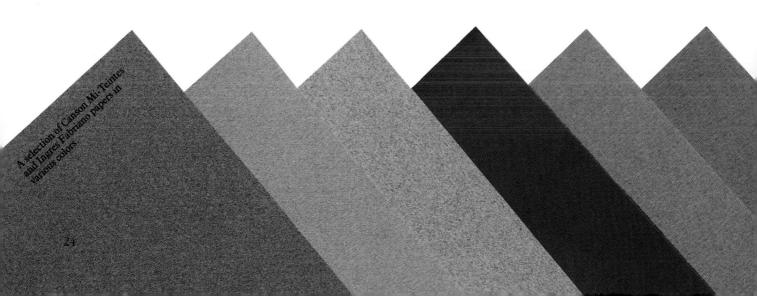

These are some of the textural effects you can get from different surfaces. The smoother papers hold the pastel more evenly, whereas pastel applied to rougher surfaces take on the grainy quality of the support. Pastel paper is available in a wide range of colors to suit your subject, but it's best to avoid strongly colored surfaces since they will fight with the colors in the painting.

COLOR

Pastel paper is available in a wide range of colors – so wide, in fact, that it can be confusing for a beginner. But it's most important that you make a considered choice, especially if you intend leaving areas of the paper showing through to contribute to the overall color scheme. I start by deciding whether I want the paper's color to harmonize with the subject or to provide a contrast. Then I decide whether the color should be warm, cool or neutral. For example, I might choose a paper with a warm earth color to accentuate the cool greens of a landscape; or I might choose a warm golden yellow to harmonize with the browns and russets of a fall scene; and I find that brightly-colored flowers project well against a neutral gray background. On the whole it's best to avoid strongly colored papers since they will fight with the colors in the painting and create a harsh, gaudy effect. If you're in any doubt, remember that you can't go wrong with muted colors such as grays, greens and browns.

TONE

Having decided on the color of your paper, you now need to consider whether it should be of a light, medium or dark tone. "Tone" refers to the relative lightness or darkness of the paper, regardless of what its actual color is. For example, the Canson range of papers contains, among other colors, several tones of gray: no. 343 Pearl is light in tone, no. 345 Dark Gray is dark in tone; no. 429 Felt Gray is middle in tone. Your choice of tone will depend

to a large extent on how light or how dark the subject is.

Light-toned papers are best when you want to emphasize the dark tones and colors in a painting. Pale tones and colors generally don't show up well on a light-toned paper.

Middle-toned papers are the most popular, particularly with beginners. They allow you to judge both the light and the dark tones in your painting accurately, and they provide a quiet, harmonious backdrop to most colors.

Dark-toned papers are the most difficult to use effectively. They are used when the light areas of the painting are to be emphasized, but in some cases they can make the lights look overassertive.

OTHER SURFACES

In addition to the papers made specifically for pastel painting, there are a number of other surfaces which are worth experimenting with.

Watercolor paper is suitable for pastel painting, so long as it is a rough-textured one, such as Strathmore papers or Fabriano Swedish Tumba. A smooth, or Hot Pressed, paper is not suitable because it is too smooth for pastels. It's best to tone watercolor paper (see opposite) before painting. This is because white paper doesn't show the vibrant colors of pastel to their best advantage – it makes them look darker than they actually are. Also, a toned paper makes it easier to judge the tones and intensities of your colors.

Charcoal paper is an inexpensive alternative for rough sketches and experimental work. However, it is rather thin and fragile, and you may find its regular, linear surface texture less than sympathetic.

Fine sandpaper has an interesting grainy texture and provides a very good buff middle tone which is suitable for most subjects. The texture grips the par-

 Brown parcel paper 2 Mars Rough watercolor paper
Saunders Rough watercolor paper 4 Saunders Not surface watercolor paper 5 Fine sandpaper 6 Flock velour paper 7 Fine-grain oil sketching paper

hing You'll Need

3

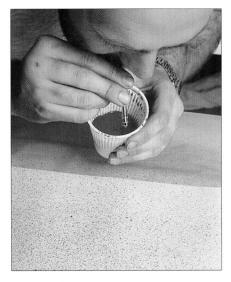

Here pastel has been used all over the paper to create a toned background and is being blended with a blending brush to create a smoother, more even, finish.

Crushed leftovers of broken pastels can be rubbed into the paper for a soft grainy effect.

A spray diffuser gives an interestingly pale stippled tint to the surface of the paper.

ticles of color well, and there is enough resistance to the drawn line to make it very pleasant to work on and give the strokes authority. With its rough surface, sandpaper is well suited to a bold, vigorous approach, though both blending and covering large areas are more difficult.

The disadvantages of sandpaper are that it shaves off the pastel fairly rapidly, making it an expensive surface to work on; mistakes are not easily erased without resorting to a knife or razor blade which could damage the paper's surface; and it can be hard on the knuckles if you hold them too close to the paper!

Pastel boards (pastel paper mounted on board by the manufacturer) are available in a range of sizes and finishes, from soft velour to hard and gritty. Some artists prefer the firm resistance of a board, and boards are certainly less likely to bend and buckle than paper.

TONING PAPERS AND BOARDS

Pastel papers and boards come in a wide range of colors, but there may be occasions when you prefer to tint your support by hand. Since tinted papers from artists' suppliers tend to fade eventually, it's a good idea to give them a wash of color if you intend leaving large areas of the paper untouched in your painting. Or perhaps you want to work on a particular watercolor paper because you like its texture, in which case the white of the paper will need to be toned down with a watercolor wash. Some artists feel that the colors of pastel papers are too flat and mechanical, in which case they can be given a partial or irregular covering of a toning color to give them a more "painterly" feel.

There are various ways of toning your own paper. Watercolor, acrylic or gouache can be applied with a brush, sponge or spray diffuser to leave a pale tint of color (make sure the paper is thoroughly dry before use). Or you could follow the ancient Chinese method of rubbing damp tea leaves across the paper's surface, which leaves a highly attractive, warm undertone (today, I suppose, wiping the paper with a used teabag would have the same effect). My favorite method, though, is to save the broken ends of my pastels and crush them to a powder with a palette knife. I then dip a damp rag into the powder and rub it over the paper. When the paper is dry, I tilt the board and tap the surplus powder off the paper.

Additional Equipment

In this section I will discuss the most important items of extra equipment you are likely to need for pastel painting. Some of these may seem obvious – easels and drawing boards, for instance – but if you're buying these articles for the first time it's important to make the right choice.

DRAWING BOARD

vthing You'll Need

For pastel painting, it is not necessary to invest in a heavy wooden drawing board. In fact I prefer to use a piece of plywood or Masonite, which have several advantages over a commercial wooden board: they're lighter to carry (useful if you're working outdoors); their surface is firm, yet relatively soft and resilient; and they can be obtained very cheaply from a local timber merchant, who will cut them to any size you like (I have several boards of different sizes, including very small ones which I can prop on my knee quite comfortably when sketching outdoors).

If at all possible, make sure that your drawing board is about 6in wider on all sides than your paper – it's amazing what a difference it can make to the flow of the picture. If the paper is the same size as the board, you immediately feel "cramped" and the edges of the picture, in particular, look tight and stilted. On the other hand, a wide margin around the paper means that you can extend your strokes beyond the paper, giving them more flow and authority. In addition, the board acts as a "frame" for the picture and somehow makes it easier to judge proportions and scale.

Attach your paper to the board with Blu-tac stuck to the two top corners of your paper. One last point – always place a pad of two or three sheets of paper between your pastel paper and the board. This gives a more resilient, springy surface to work on than a single sheet, and your pastels are also less likely to snap while you are working.

EASEL

Since pastel painting requires the application of a

degree of pressure, it's important to have an easel that is sturdy and that doesn't wobble or slide as you work. It should also be adjustable to any height so that the board is at eye level whether you work sitting or standing. If you do a lot of outdoor work, however, choose a light, portable telescopic easel.

WORK TABLE

You will also need a sturdy table on which to hold your pastels and equipment. Ideally the table should have wheels or castors, and be small enough so that you can swing it between yourself and the easel while working. A raised rim around the edge of the table top will prevent the pastels from rolling off. I find an old TV table suits the purpose admirably, and it has a shelf below the table top for holding jars, rags, fixative sprays and other paraphernalia.

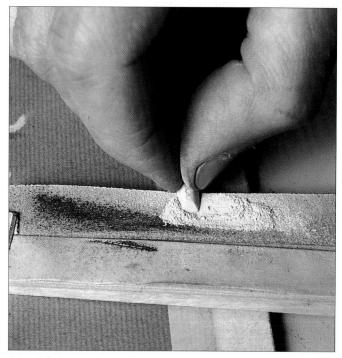

Razor blades can be used to sharpen pencils, but a safer method is to rub the stick gently across a rough surface like sandpaper.

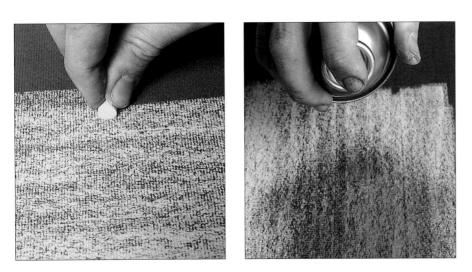

Some artists fix their pastels as they go along and then fix them again when the painting is complete. Here the color is being built up thickly using the side of the stick. It is then fixed, which allows further layers to be added without risk of smudging. This darkens the color slightly, which can be an advantage as long as you are aware of the effect.

FIXATIVE

A pastel painting is a fragile thing that can easily be smudged or smeared unless handled with great care, particularly during the process of mounting and framing. One answer to the problem is to spray the completed painting with fixative - a thinly diluted varnish that binds or fixes the pastel particles and forms a thin, clear, protective coating.

Fixative is most commonly available in aerosol spray cans, which are convenient to use and cover a large area quickly, though they do give off unpleasant fumes that take some time to disperse. Alternatively, there are mouth diffusers, which have a plastic mouthpiece through which you blow a fine mist of fixative. Mouth diffusers are cheaper than aerosol cans are and give you a greater degree of control when spraying a small area. They do tend to clog easily, but this can be prevented by passing a thin wire through the tubing immediately after each use.

THE PROS AND CONS OF FIXING

To fix or not to fix? That is the question which causes more controversy among pastel artists than any other. Some artists object to its use on the grounds that it alters the character of the painting, destroying the soft, velvety bloom that is one of the greatest charms of pastel work. The reason for this is that the particles of pastel absorb the moist fixative and coalesce – they become thicker and heavy like a paste, and resemble distemper paint rather than pastel. It's also true that heavily applied fixative tends to dissolve and blend the pigment particles so that the colors are altered. Whites, for example, may become tainted by underlying or adjacent colors. Fixative can also darken colors, thus altering the tonal balance of a painting.

As an alternative to spraying with fixative, you can simply lay a sheet of tissue paper or cellophane over the painting, then cover it with a board and apply pressure. This pressure fixes the pastel particles more firmly into the grain of the paper without affecting its surface.

There is a theory that pastel also fixes itself automatically in the course of time because of the moisture in the atmosphere, which acts on the size in the paper and the gum in the pastel; the older a pastel is, the more solid it becomes.

Defenders of the use of fixative claim that it can add much to the tactile quality of the painting, giving it a richness and solidity that is more akin to an oil painting. Some artists apply fixative several times during the progress of the painting, each time working the color in over the fixative and building it up in heavy layers (a method called impasto). This sprayverything You'll Need

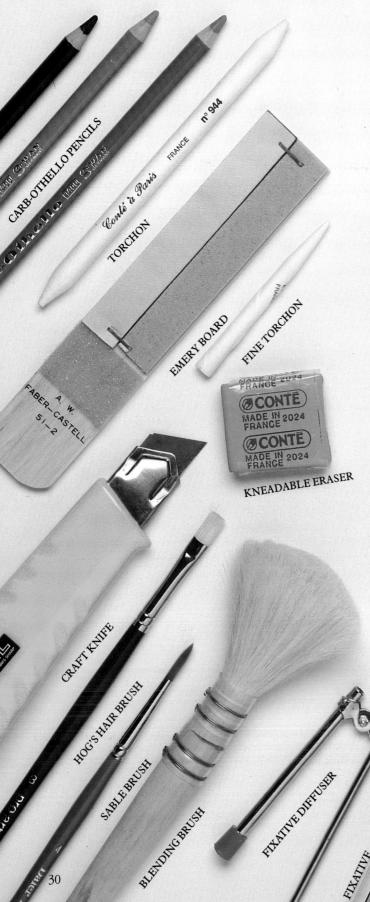

and-paint technique was often used by Edgar Degas (1834–1917), who was nothing if not innovative in his approach. Indeed, Degas used fixative almost as a mixing medium, sometimes creating a thick paste of pastel and fixative which he then worked into with a stiff brush.

The darkening effect of fixative can also be used to advantage by the wily artist: if you find that the tone of a particular color is too light, a quick spray of fixative will not only darken it but also allow you to work further colors over it if you wish, since it isolates the color underneath.

So there you have it. By not using fixative you retain the freshness and delicacy of the medium, but at the risk of smudging, smearing or flaking. By using fixative you create a painting that stands up to wear and tear, but that looks more like an oil painting than a pastel painting.

Personally, though, I find it's possible to reach a happy compromise: I simply fix my painting just before it is finished – not at the very end. This way, the colors in the final layer look bright and fresh, but the underlayers are fixed, so the dangers of smudging and smearing are minimized.

Another way of fixing safely is by spraving the work from the back. Hold the work up in one hand and spray lightly across the reverse side; the fixative will soak through the paper to dampen the pastel and hold it in place, without disturbing the surface.

HOW TO APPLY FIXATIVE

Spraying a painting with fixative requires a delicate touch. Aerosol sprays, particularly, can be a bit fierce, so if you haven't used one before it's worth practicing on pieces of scrap paper until you discover how to produce a fine, uniform mist without getting any drips on the paper.

TURPENTINE

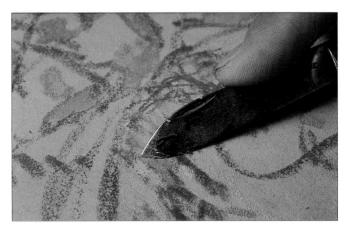

Mistakes can be erased with a single-sided razor blade or a sharp knife.

A common mistake is to hold the spray too close to the surface, so that the pastel becomes oversaturated and the colors lose their brilliance. The idea is to produce a fine mist that floats down lightly over the pastel – not a gushing torrent that knocks the pigment off the paper.

The best procedure for fixing a painting is this: first of all, gently tap the back of the board to dislodge any loose particles of pigment from the paper. Standing three to four feet from the easel, begin spraying just beyond the left side of the picture. Sweep back and forth across the picture with a slow, steady motion, always going beyond the edges of the picture before stopping. Keep your arm moving so that the spray doesn't build up in one spot and create a dark patch or start to drip down the paper.

When fixing a completed painting, remember that it should be applied carefully and sparingly; two or three light coats are better than one heavy one. Finally, always work in a well-ventilated area so as to avoid inhaling too much of the spray.

MAKING YOUR OWN FIXATIVE

It is perfectly possible to make your own fixative, which can be applied with a mouth spray. The advantages of homemade fixative are, first, that it is cheaper, and second, that it evaporates quickly and doesn't darken the pastel colors appreciably.

A friend of mine, who is a paper conservationist, has given me a formula for a non-staining, absolutely

clear and permanent fixative – and it doesn't involve the use of flammable or toxic fluids. All you do is dissolve $2\frac{1}{2}$ leaves of gelatin (or $\frac{1}{2}$ teaspoon of gelatin powder) in 2 pints of warm water and leave it for two hours. Spray the mixture on while it is still slightly warm, otherwise it will eventually begin to set.

For a really fast-drying fixative, make a solution of one part mastic varnish to 25 parts ethyl acetate or butyl alcohol. Always work in a well-ventilated room.

TOOLS FOR ERASING

A pastel painting loses its freshness and looks dead when it is overworked, so if you are going to have second thoughts, you should have them at an early stage when there is not too much pastel on the page. Erasing can also spoil the surface texture of the paper, so should be done with care. After erasing, a light spray of fixative will facilitate further reworking.

Razor blades (the single-edged type) should be used to scrape away pastel particles before finishing off with an eraser. Hold the blade flat against the paper and scrape lightly, no more than two or three times. Razor blades are also used for sharpening pastel crayons.

Kneaded erasers are useful because they can be pinched into a small point for erasing small areas (a small piece of kneaded white bread also works well). Never rub pastel with an eraser – it will make the surface turn slick and greasy. Press the eraser firmly against the offending area and lift the pastel particles away. The eraser should be kept clean by wiping it frequently on scrap paper.

Bristle brushes (the kind used in oil painting) are the kindest way to brush away pastel particles in those areas that haven't been heavily worked. The loose particles should then be lifted off with an eraser.

Torchons (paper stumps) are narrow tubes of rolled blotting paper used for blending colors. You can use your fingertip just as easily, but torchons (also called tortillons) are rigid and pointed at the tip, so are good for small, fiddly areas. They also minimize the risk of grease from your skin spoiling the painting.

Pastel Techniques

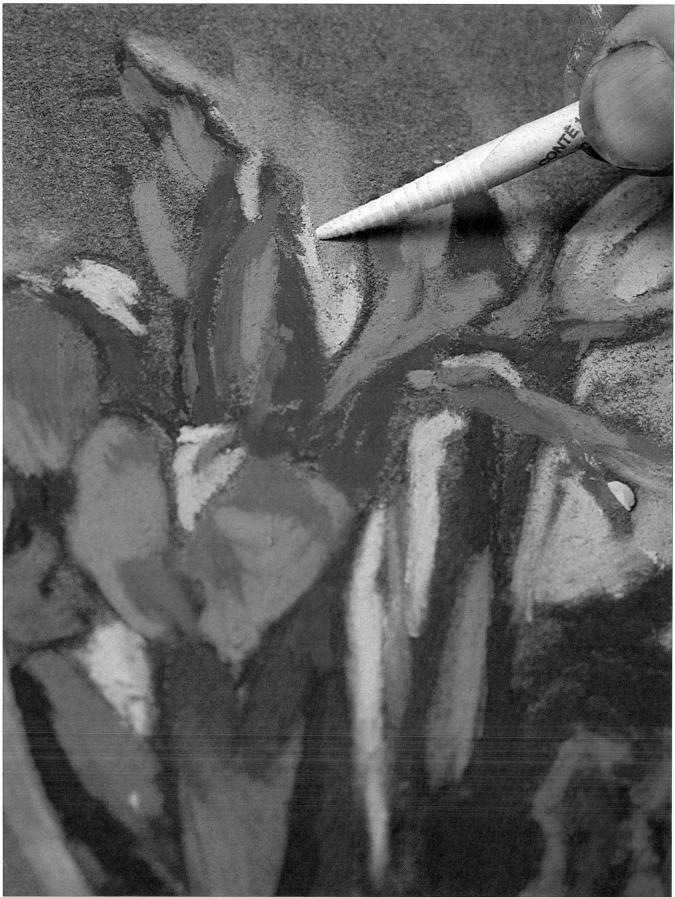

CHAPTER THREE

PASTEL TECHNIQUES

The unique quality of pastel is that it is both a painting and drawing medium. Working with the side of the pastel crayon creates broad, painterly strokes that can be blended and smudged or built up in thick impasto layers with the solid, buttery appearance of an oil painting. Working with the tip of the crayon, you can make thin lines and crisp strokes that create an altogether different feel: here, the color and texture of the paper play an important role, with the sparse lines and strokes of pastel giving a delightfully sketchy impression of the subject.

As we will discover in this chapter, there are many ways of applying pastel, and the "painting" and "drawing" techniques can be used beside each other to create a breathtaking range of textures and effects. Add to this the different effects achieved by using soft and hard pastels, rough and smooth papers, and different colored papers, and you will begin to see why pastel is such an expressive and fascinating medium to work with. Technique, however, should never be seen as an end in itself. It is far more important to observe your subject carefully and then decide which technique best expresses particular aspects of that subject.

> Here a torchon is being used to blend colors together. Blending can be done with a rag or with the finger, but the torchon, a paper stump rolled to a point, is best for small areas like this.

Linear Strokes

Each of us has a handwriting style that is unique and personal to us alone. Whether our writing is neat and precise, or full of flamboyant loops and curves, it unconsciously expresses something of our personality. The same thing applies to drawing; every line and stroke an artist puts into a drawing or painting expresses something about the artist as well as the subject. A classic example of this is to be found in the violent, swirling lines in the paintings and drawings by Vincent van Gogh (1853–90), that express the

tel Techniques

intensity of the artist's emotions and the tortured state of his mind.

Much can be learned by experimenting with linear strokes in pastel. You don't have to draw actual objects, though you may like to make gestural strokes which resemble the shapes of leaves, clouds, or waves. Otherwise, you can simply make abstract doodles – anything, in fact, that helps you to get the feel of the medium. The main thing is to keep your mind relaxed and your drawing wrist supple, and

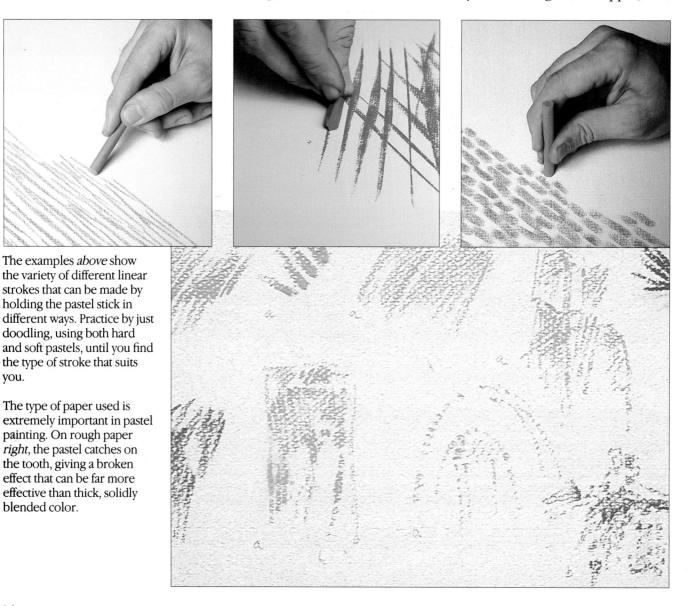

mst - 05:01 Jack Sat 10:30 - 2 am

029-201

xe1 + 02.32

Sandwich Special of the Month Two Chicken Breasts with Pancetta, Aged Vermont Cheddar, mustard, mayo, lettuce, tomato, red onions, and pickles served hot on our nomemade focaccia bread!

12" \$14.80 + 12" 16" \$20.55 + 1ax 16" \$20.55 + 1ax

<u>September Pizza Special</u> of the Month Farmer's Market Roasted Shallots, Balsamic Reduction, and topped with sliced and topped with sliced

At first, the marks you ations ad, but gradually you'll of lin and more eager to ones; begin to recognize the Use b beal to you – the ones rough

hality. essive medium to draw t of the crayon, or altertwo and use the sharp /hen one corner wears t to find a new one. By yon you can create a s, and by varying the can create tonal gradations from light to dark. Try making different kinds of lines – precise, patient ones; sketchy, impulsive ones; nervous, staccato ones; and sweeping curves. Use both hard and soft pastels, and try them on rough- and smooth-textured papers. A soft pastel on smooth paper glides effortlessly, leaving behind it a satiny trail of vibrant color; the same pastel used on rough paper gives a splattered, irregular line because the tooth of the paper breaks up the color and leaves tiny dots of paper showing.

The examples shown below demonstrate just some of the possibilities. Copy these if you find it helpful, but try to come up with some ideas of your own too.

On smooth paper *above*, the pastel strokes will be much denser, particularly if the pastel is pushed into the surface.

35

Side Strokes

Having experimented with the tip of the pastel crayon, you're now ready to try one of the most beautiful and expressive strokes in pastel painting – the side stroke. For this, you'll need a short length of pastel – anywhere between ½in and 2in long (so hang on to your broken pieces). Using the entire length of the side of the crayon, press it against the paper and make swift, sweeping strokes across the page.

Numerous effects can be achieved with side strokes by varying the pressure on the crayon and using different movements of the wrist. Heavy pressure forces more pastel particles into the tooth of the paper to create a solid, dense quality. When applied lightly, the tooth of the paper shows through the color, creating a random, broken texture that seems to scintillate with light. As you work, you will soon see the importance of the tooth and the color of the paper, both of which have a direct influence on the finished effect. Try it with hard and soft pastels, and on different grades of paper; work with dark colors on a light ground and vice versa; vary the pressure from hard to soft within a single stroke to see how it creates a gradation in tone from dark to light. Be inquisitive – the knowledge you gain will stand you in good stead when you later come to paint pictures.

Side strokes are excellent for covering large areas in a painting, such as the background in a portrait. When used on rough paper, the grainy effect produced can be used to suggest specific textures, such as tree bark, woven fabric, or perhaps a pebbly beach. However, bear in mind that this technique works best when used judiciously and as a contrast to linear work: the attractiveness of side strokes can lead you to use them too much, resulting in the weak, "cotton candy" sort of image that has unfortunately given pastel painting rather a bad name in the past.

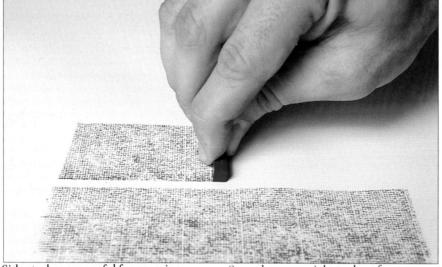

Side strokes are useful for covering large areas. They are also one of the most expressive of all the pastel strokes, and many different effects can be created by varying the pressure of the pastel on the paper.

Smooth papers *right* are best for detailed work or fine lines, but because they have little tooth to hold the pastel particles they quickly become clogged if too many layers are worked on top of one another.

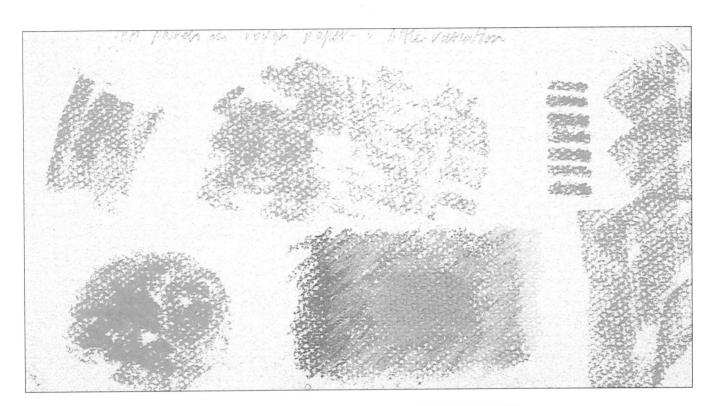

The texture and color of the paper are more important in pastels than in other forms of painting because pastels sit on the surface of the paper rather than staining it as paints do. Light strokes made on a rough surface *above* will give a broken texture, and the same strokes made on a dark or brightly colored paper will immediately form a two-color combination, as the paper color will shine through the pastel.

1.1

Blending

The advantage of a powdery medium like pastel is that it is easily blended to create a large range of subtle and beautiful effects. Two or more colors. either adjacent or on top of each other, can be fused together softly by blending with your fingertip, or with rags, tissues, brushes or paper stumps (torchons). Fine lines and details can be softened, tones lightened, shapes tied together – there are all manner of things you can do with the blending technique. But before I go on to discuss these in more detail, let me introduce a note of caution: just like side strokes, blending is an easy way to achieve attractive, "soft focus" effects. But it should not be over-used or your picture will lack definition and take on that slick. sentimental look so beloved of the less talented pavement artists you find in tourist resorts. Blending should be used for a purpose - not just because it looks pretty. Use it beside other, more rugged, techniques, or spray the blended area with fixative and then go over it with some lively, broken strokes.

COLOR GRADATIONS

In nature, you'll find a variety of edges, some defined and some gradual. In some, one color or tone will end and another begin as in a dark leaf against a sky, but more often, they merge gradually one into the other. Think of a hazy sunset sky, for example, in which blue fades imperceptibly into yellow, then into shades of pink, orange and red as it nears the horizon. In a pastel painting, you can achieve this effect by laying in bands of color using side strokes and then blending together the edges where the colors meet.

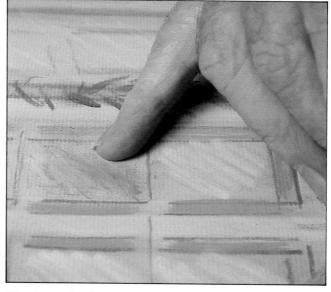

Blending with a finger is quite satisfactory if the part to be blended is a suitable size — too large an area could be hard on the fingers.

Soft pastels, being powdery, can be blended very easily, and using a rag is a good method for large areas.

Here a soft sable brush is being used to blend certain areas of the picture quite lightly to soften the effect without removing the pastel particles from the surface.

For fine blending, or very small areas, a torchon is the tool to use. These can either be bought or made yourself by rolling paper tightly to form a point.

This series shows the very subtle effects that can be created by blending one color into another using soft pastels. Only three colors have been used, orange-pink, yellow and pale green, and all are similar in tone so that they appear to run into one another. astel Techniques

When light strikes a rounded object it creates a light area, a middle-tone area and a dark area as the form turns gradually away from the light and into shadow. Pastel is particularly well-suited for rendering such tones because it is so malleable, and can be blended and softened to an almost infinite degree to achieve a convincing sense of three-dimensional form. For this reason, blending is often used in portraits, particularly those of young children with soft, rounded features.

SOFTENING EDGES

You may have heard artists and art teachers talking about "hard and soft" edges, or "lost and found" edges. What they mean by this is that the outlines and edges of some forms appear crisp and well defined, whereas others appear softer and more blurred. Compare the contours of a jagged rock, for example, with those of a cloud. However, even within that rock or that cloud you will find a variation in edges between hard and soft.

In pastel painting, hard edges are created by drawing an outline with the sharpened point of the crayon; soft edges are created by smoothing or blending the outline to soften it. It's very important to introduce a variety of hard and soft edges in a painting, because it helps to give weight and solidity to the forms. For example, where an object faces into the light its edge appears soft and blurred, while on the opposite, shadow side, the edge appears crisp and hard. By observing these small changes and rendering them in your painting, you will achieve a convincing sense of form. In addition, the transition from hard edges to soft ones within a painting creates a rhythmical flow of movement which adds interest and helps to guide the viewer's eye through the composition.

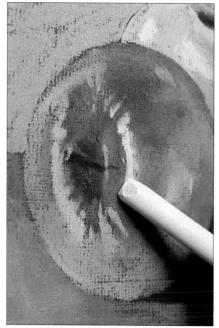

A rounded object is defined by the way the light strikes it, creating shadows and highlights of a particular shape. Here the highlight is being drawn in with white pastel.

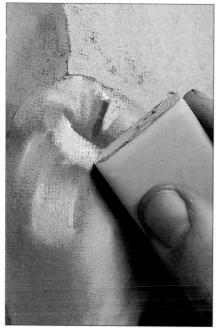

Leaving the sharp line of white would have looked unnatural, so the artist now blends it carefully into the surrounding colors so that it is soft-edged but still distinct. Care is taken to retain the shape as this describes the shape of the fruit itself.

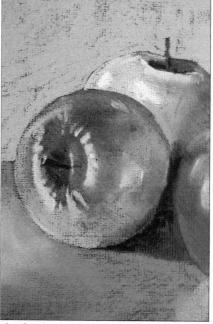

The finished effect of the group of apples is solid and convincing, and they have been anchored firmly to the flat plane of the table top by the gray-blue shadows which become darker against the light sides of the fruit.

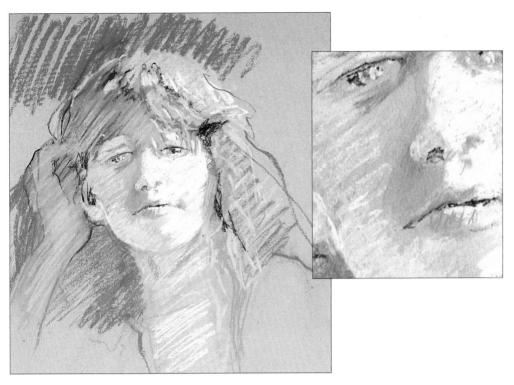

In this portrait dramatic use has been made of hard and soft edges. Notice how the artist has defined the eyes by using sharp, fine strokes of black, repeated in the inner line of the lips. Other areas, such as the shadow side of the nose and the bottom lip, have been softly blended to suggest the more rounded forms.

Hard and soft edges are also used in the landscape but in this case very subtly, as this artist's approach is gentler and less linear. The reflections in the water have been slightly blended to give a soft impression of movement, while the eaves of the roofs and small details such as windows have been picked out with fine, delicate lines.

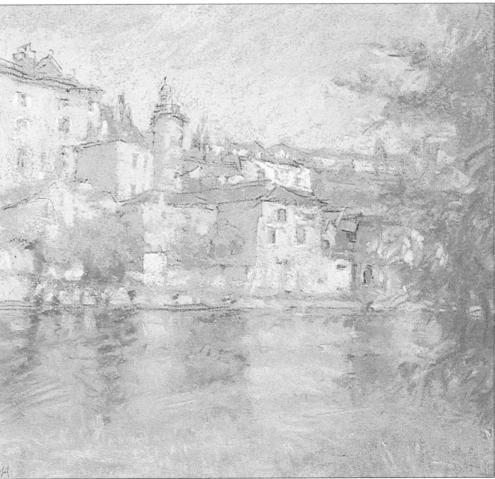

CREATING DEPTH

el Techniques

As a follow-on from the idea of hard and soft edges, remember that blending some edges and not others will also create the illusion of depth and space. Objects appear more blurred and indistinct the farther away they are, and the tonal differences become much smaller, so in a painting of a distant landscape space and recession can be conveyed by softening the forms of trees or hills on the horizon, and blending them into the color of the sky.

MIXING COLORS

As well as blending adjacent colors, you can also apply one color on top of another and blend the two to form a third color. For example, by applying strokes of red over strokes of yellow and rubbing them together with your fingertip, a rag or a torchon, you can create an orange, the specific shade depending on the particular red and yellow. You can either blend the colors entirely, or only partially, so as to create a broken-color effect which appears more vibrant.

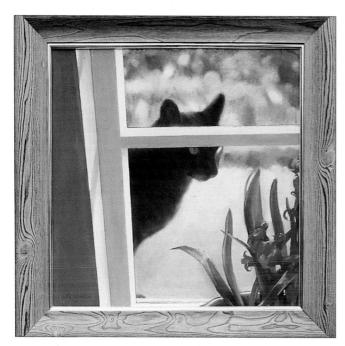

In this pastel, the feeling of depth has been created mainly by defining the window in the foreground so crisply and sharply. The cat and flowers are obviously just outside the window, while the foliage beyond, in pale, cool colors blended into one another, recedes to a more distant plane.

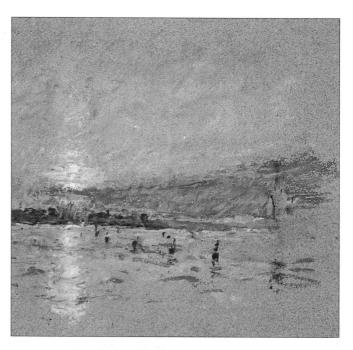

The lovely, glowing sunset scene *above* owes much of its effect to the way some colors have been modified by being laid one on top of another while others have been used quite pure, shining through with extra brilliance against the neutral color of the paper.

The photograph *left* shows some of the different effects that can be created by laying colors on top of one another so that they blend visually. In the first example, light brown has been applied over dark blue-gray; in the second the same color combination has been blended with the fingers; while the third uses the same technique as the first but with paler colors dove gray and beige.

Feathering

What can you do when an area of your pastel painting looks too bright/dark/warm/cool? What if you've overblended a color and it's gone dead on you? These problems cannot always be avoided, and they can be difficult to correct in pastel without ruining the surface of the paper. However, the feathering technique can provide a means of rescue, because it allows you to alter or enrich a color subtly without having to resort to erasing or scraping. In addition, feathered strokes can be used to unify shapes and colors and to soften and blur an over-hard edge.

Feathering couldn't be simpler – all it involves is making light, feathery, diagonal strokes of one color over another, so that the underlying color still shows through but is modified by the feathered strokes. For example, if a certain red looks too hot you can tone it down by feathering over it with strokes of its complementary color, green. If you've painted an area gray and it looks dull and flat, liven it up with feathered strokes of yellow or red.

This technique works best with a hard pastel or pastel pencil – soft pastel may smudge and cover the layer below too much. Don't press too hard – use a light, feathery touch to float the color on top of the existing one.

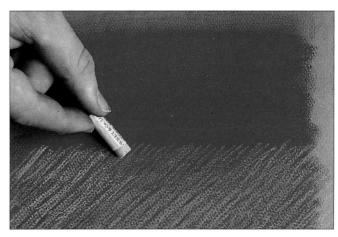

Feathering *above* involves making light diagonal strokes over another color, and it is a useful way of enlivening a dull, flat area. Here light color is being feathered over dark to lighten the area as well as to create texture.

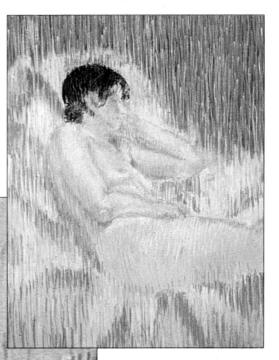

A technique related to feathering has been used for the nude study *above and left*, but in this case the strokes are vertical rather than diagonal as the artist wanted to use them as a contrast to the horizontal emphasis of the subject itself.

Cross-hatching

Cross-hatching is the classic drawing technique in which tones are built up with lines criss-crossing each other in opposite directions. Simply by varying the density of the strokes, you can create a wide range of tones; closely spaced lines with a dark pastel on a light-toned paper will create a dark tone, and widely spaced lines a light one, whereas for a light pastel used on a dark paper the opposite applies.

astel Techniques

By interweaving different colors you can achieve particularly vibrant color mixtures. Each hue retains its own identity, but blends partially with adjacent colors in the viewer's eye to create a new color which can be much more interesting than a single area of flat color. Also, the lines themselves have life and movement, adding considerably to the surface interest of the painting. For example, when crosshatching is used in a figure painting, it somehow conveys the impression of life more effectively than flat color does.

Being a linear technique, cross-hatching has an

advantage over blending in that dense, glowing color can be created without prematurely filling up the tooth of the paper, thus retaining a fresh, lively appearance.

Cross-hatching works best on a smooth paper, and can be used with all types of pastel, separately or in combination. However, hard pastels and pastel pencils are the most suitable for this technique because they give sharper, crisper lines. For even greater textural variety, the cross-hatched lines can be softened partially in places by stroking them lightly with your thumb.

Cross-hatching is normally done with diagonal strokes running in opposite directions, but you can also build up a denser web of color by running lines in several different directions – horizontal and vertical, then diagonally in both directions. Practice these techniques, and try different color mixtures on a variety of toned papers to see what effects you can create.

There is almost no end to the effects that can be achieved by altering the space and direction of cross-hatched strokes. Here diagonal cross-

hatching has been used on top of vertical and horizontal strokes.

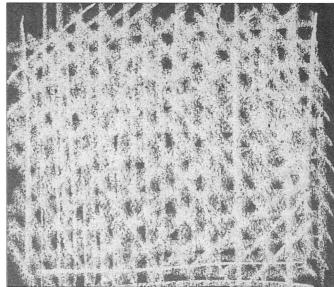

In this example the same strokes have been used, but in four different colors, which vastly extends the possibilities of the technique.

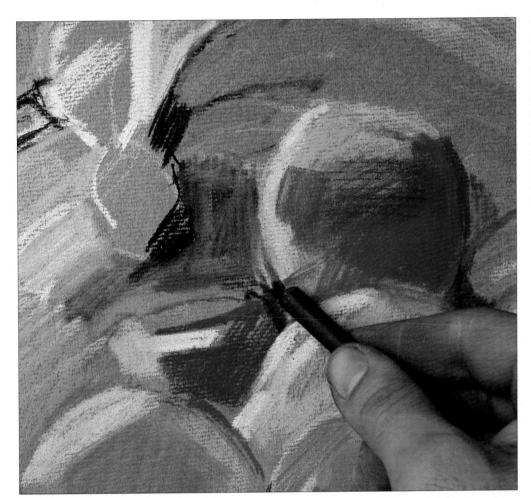

This detail of the still life illustrated on pages 96–101 shows how effective the cross-hatching technique can be when building up forms and colors. The artist used soft pastels first to lay in broad areas of color quite lightly. He then overlaid these with fine strokes of crosshatching, using pastel pencils, and finally picked out the darkest shadows in black.

Altering the pressure used so that some strokes are thicker than others gives even further variety.

Here an interesting pattern has been formed by making several small groups of crosshatched strokes in different directions.

Scumbling

Like feathering, scumbling is a method of modifying the color of a toned paper or a layer of pastel by applying a thin, opaque layer of another color over it. Whereas feathering uses hatched strokes with the point of the pastel, scumbling involves using the side of the stick in a loose motion to create a thin veil of color which doesn't entirely obliterate the one underneath. The two colors mix optically and have more resonance than an area of flat, blended color does – the effect is rather like looking at a color through a thin haze of smoke.

stel Techniques

Scumbling not only creates subtle colour effects, it also gives a very attractive surface texture. Use it to give depth and luminosity to your colors and to soften and unify areas of the painting.

To scumble, use the side of the pastel and make small, circular movements over the area to be covered. Apply only very light pressure, and don't overdo it or the underlayer will be completely covered and the effect will be lost. Soft pastel, in particular, requires a very light touch. This technique works best on a paper with plenty of tooth, which won't become clogged too quickly.

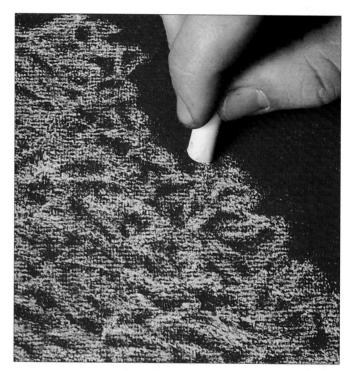

Scumbling creates interesting effects of both color and texture. Here a light pastel is being used on dark paper.

Scumbling light over dark, as here, gives a pleasing shimmer, as the colors are broken up in an irregular way.

This reverses the previous effect: dark colors were worked on top of several lighter ones.

The vibrant area of color was produced by scumbling light and dark together.

Pointillism

The word pointillism is derived from the French word *point*, meaning dot. The technique of pointillism involves building up areas of tone or color with small dots of pure color which are not joined, but leave some of the toned paper showing through. When seen from the normal viewing distance, these dots appear to merge into one mass of color, but the effect is different to that created by a solid area of blended color. What happens is that the incomplete fusion of the dots produces a flickering optical effect on the eye; the colors scintillate and appear more luminous than a flat area of color. If complementary colors are juxtaposed, the effect is even more pronounced. For example, when dots of red and green, or yellow and violet, are intermixed, each color intensifies the other and the effect is strikingly vibrant. However, it is important to note that this vibrancy is only achieved when the colors are of the same tone.

The color of the paper can also contribute to the finished effect, appearing between the dots of color and harmonizing or contrasting with them.

Pastels are particularly suited to the pointillist technique because of their pure, vibrant hues and ease of manipulation. Hard pastels and pastel pencils work best – soft pastels are apt to smudge.

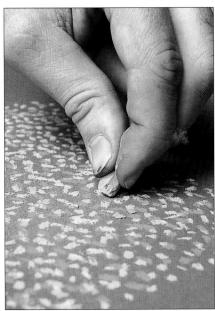

Hard pastel or pastel pencils are best for this technique, as soft ones smudge too easily. The idea of pointillism is to place small dots of bright colors next to one another so that from a distance they appear to merge into one area of shimmering, broken color.

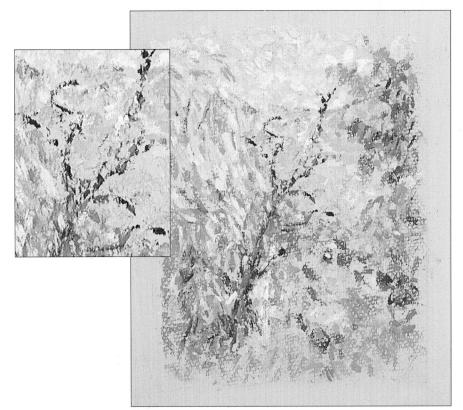

A similar technique has been used here to give a sparkling look to a delicate subject — a distant village seen through trees. The pinky-beige color of the paper, large areas of which have been left uncovered, gives an overall warmth and sunny tone to the picture, and the blobs and dots of pastel have been varied both in tone and in size.

Summer Hedgerow

OIL PASTELS ON FINE SANDPAPER

Landscapes can be a challenging and rewarding subject-matter for the pastelist, but the choice of pastel type should be made with the particular subject in mind. Obviously, the delicate effects which soft pastels offer would not suit the dramatic shape of the ferns in the foreground here, and the artist has understandably chosen oil pastels for their directness and boldness. These pastels are also useful when working outdoors, as they don't crumble as easily as soft pastels and are less likely to smear. Fine sandpaper was chosen as the support, as it offers an interesting grainy effect. You have to be very positive when using either sandpaper or oil pastels, as the artist here has been, using strong, taut strokes to describe the ferns' silhouettes, and filling in the sky quite thickly so that hardly any of the support shows.

stel Techniques

1 Oil pastels don't blend nearly as easily as soft pastels and it is difficult to get such a wide range of strokes. Here the artist is marking out the

silhouette of the ferns with sharp staccato strokes in dark blue, set next to lighter green and lilac strokes. Already exciting textures are appearing.

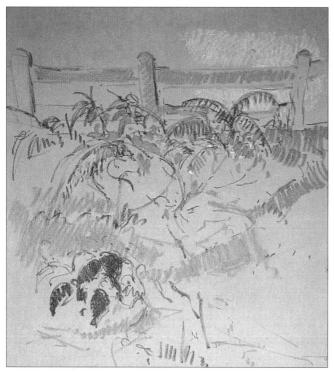

2 Most of the image is made up of very freely handled strokes, but there is an interesting contrast between the dense treatment of the leaves and the cross-hatching used for the fence and sky. This gives the picture a pleasingly lively feel, much suited to the wayward character of the foliage.

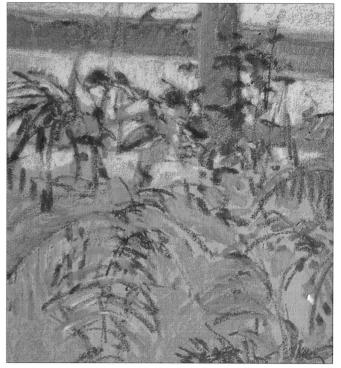

3 This detail shows the many stroke effects you can achieve by using sandpaper as a support. Some of the strokes have a broken texture where the sandpaper shows

through, whereas others, like the lilac strokes, appear more solid because the oil color clogs into the tooth of the paper.

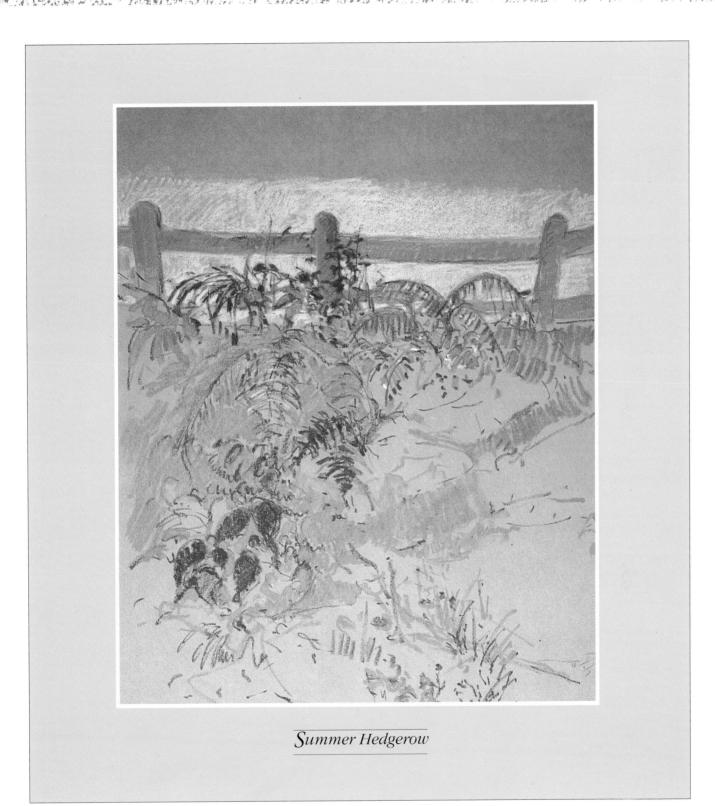

4 Tiny dots of color pick out the shape of flowers and help them to stand out from the general blue/green of the rest. The picture has been deliberately left with an

unfinished look, which allows our imagination to do the rest so that we in a sense participate in the painting.

SOFT PASTELS ON A FLOCK VELOUR PAPER

The powdery, hazy effects which soft pastels offer are ideally suited to animal subjects. In this case, careful attention was given to the choice of support, as the artist wanted to create an overall softness in keeping with the kitten. He chose flock velour paper which, with its fine fluffy texture, provides an ideal support as the surface catches the light and emphasizes the delicate look of the subject. It has its disadvantages, however: it does not hold the pastel particles very well, so there is a problem that work can easily be smudged, and fixative cannot be used with it because all the fluff comes away from the backing — so tread warily.

The artist worked from a large set of soft pastels, 13 of which were used here, quite a small range. For the kitten's fur gradations of grays and browns were used, built up layer by layer to imitate the soft, fluffy look of the actual fur. These areas were easily blended with a finger, but the artist chose to define the face much more sharply in contrast.

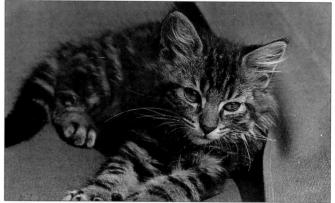

1 Photographs can provide a useful reference for wild-life subjects, but care must be taken not to produce a dull, lifeless pastel by trying to "copy" too exactly.

2 Velour is an interesting surface to work on, and given the type of subject, I think the artist has made a good choice. Soft pastels suit velour best, but it does not hold the pastel particles as well as other supports. This means that mistakes can easily be corrected by using a stiff brush. The artist starts right by marking out broad areas of fur, which he then defines more sharply by black linear strokes suggesting the kitten's markings. A very light brush of pink is used for the inside of the ears.

istel Techniques

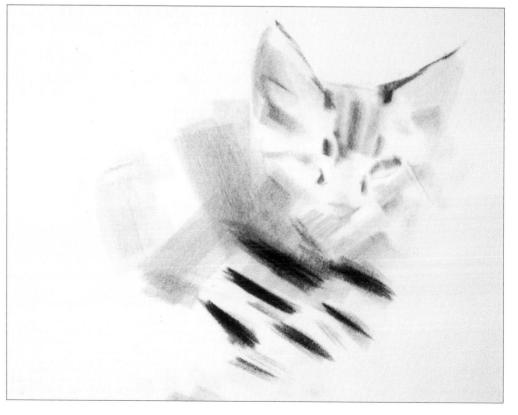

3 Stronger markings in black define the forehead *right*, which will be smudged into the other colors to increase that soft hazy look.

4 The bulk of the body *below* is then mapped out using a variety of broad overlapping strokes in different tones of grays and browns. Payne's gray helps to highlight the eyes, and is also smudged around the jawline to create the shadow which throws the white chin into relief.

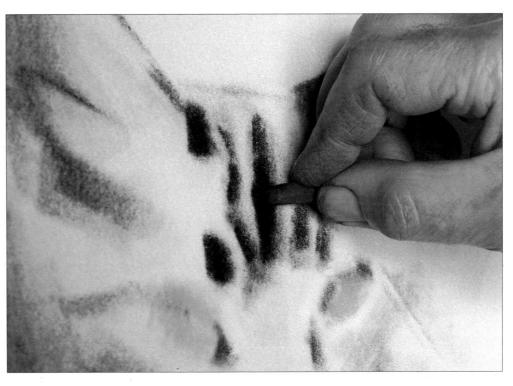

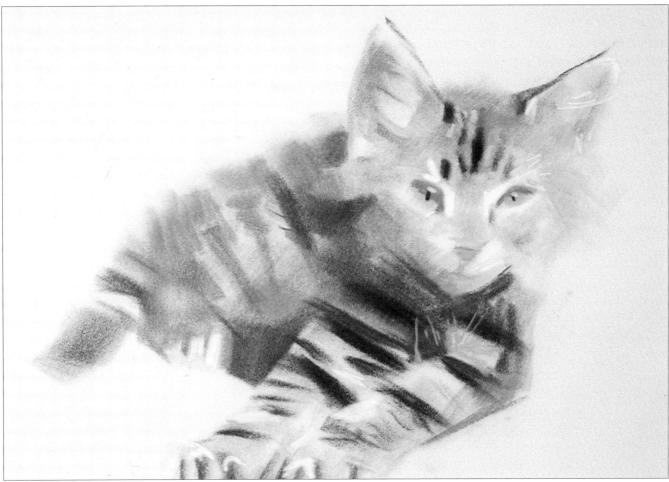

5 Here *right* the artist is using a torchon to blend the pale area around the eye. He aims at maximum definition in the features, but takes care to keep the soft, velvety texture.

astel Techniques

6 The head *below* is now a mass of built-up color which vividly suggests the texture and markings of the fur. To bring out the details of the cat's features, the artist draws in the whiskers, with long sweeping strokes of white, using the corner of the pastel.

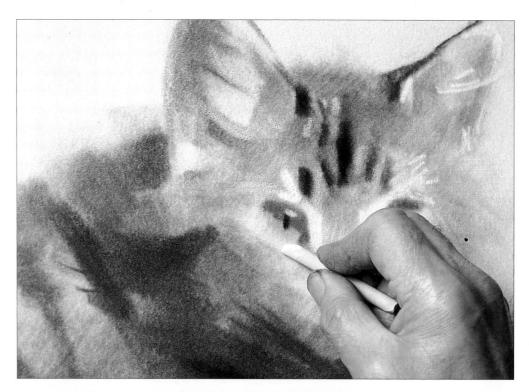

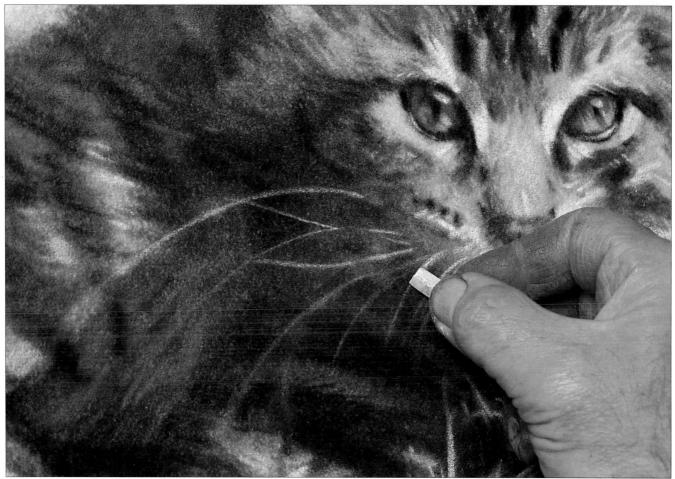

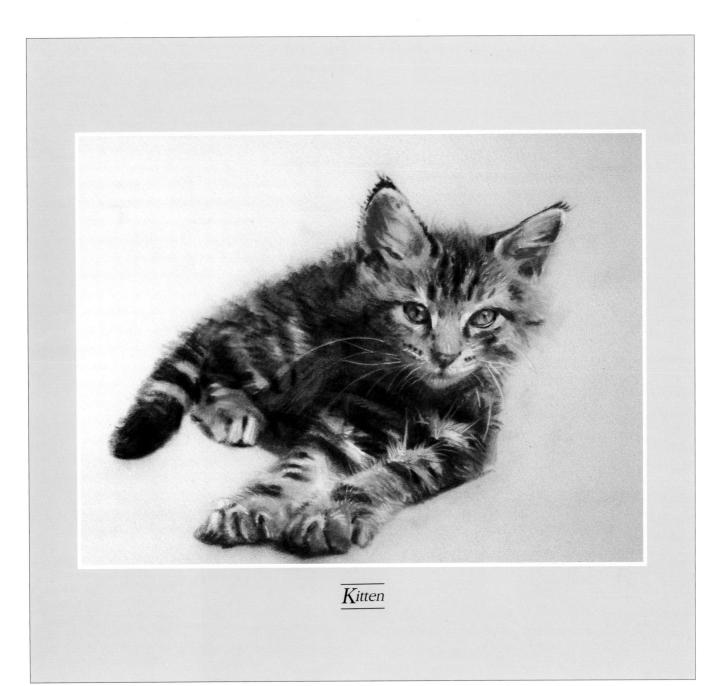

7 The beauty of velour lies in the way its texture captures light – a most appropriate effect for this subject. The central area of the picture is more detailed so the viewer's attention is drawn to it. Care must be taken to avoid overworking these details. In contrast, the artist has used his finger to smudge the outside areas of tail and paws to increase the soft, furry look, leaving the face itself crisp and clear.

SOFT CHALK PASTELS AND CONTE PENCILS ON DARK GRAY MATTING BOARD

Pastel papers and boards come in an exciting range of colors to suit the mood of your subject, and in this example, the artist has chosen a dramatic dark slate gray matting board to off-set the delicacy of the birds, which might otherwise have looked a little insipid.

astel Techniques

A wide variety of light-colored soft chalk pastels was used here, as these seemed particularly suitable for the texture of the birds' feathers, and fine details were drawn with white and pierre noire conté pencils. Notice how the edge of the pastel is used at full strength and then blended out thinly toward the dark of the support. Any smudges would show up drastically on such a dark support, and the artist had to be extremely careful when blending and cleaning up, using a rag wrapped around the handle of a paintbrush.

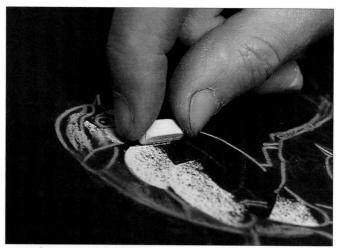

1 As this is quite an intricate composition, the artist began by mapping out the design in white outline, and here he is beginning to fill in the body of the bird with soft, powdery pastels. I like the choice of a

dramatic dark support for this subject; not only does it help give depth to the image – it also adds a touch of strength to a theme which could easily become "picturesque" and a bit sentimental.

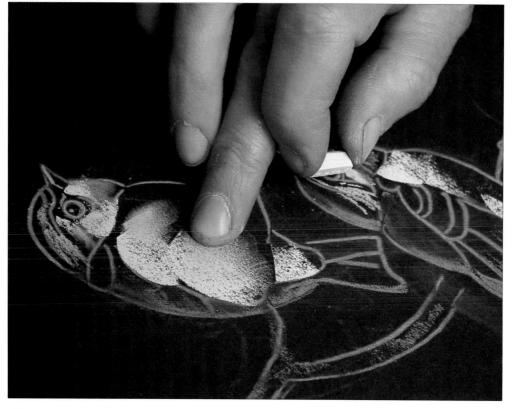

2 Soft pastels blend very easily, so are an ideal choice for suggesting the birds' feathery crests. By dragging only part of the color across the crest *left*, the artist manages to avoid a dead, tooslick look, and instead creates a lively contrast of textures.

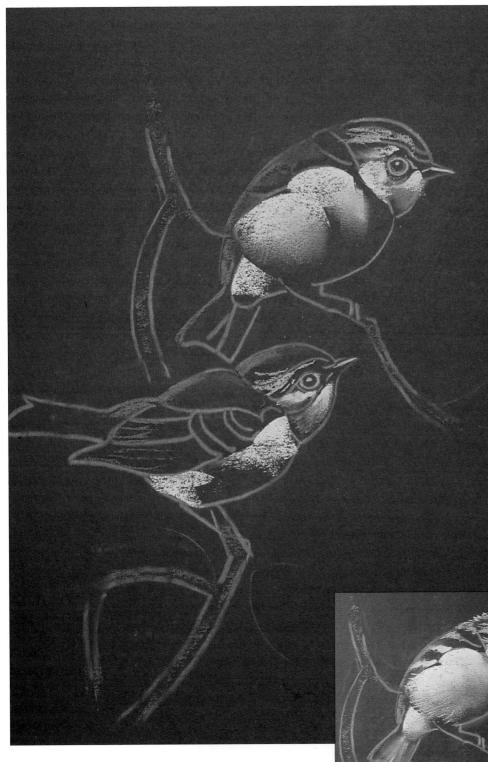

3 The color of the branch is dabbed in *left* with light broken strokes of olive green, and I think this blends in quite effectively with those velvety highlights on the birds' wings.

4 For larger areas like the bodies, finger blending is ideal, but when it comes to fine details like softening the contour of the crest, it is much easier to use a rag wrapped around the handle of a paintbrush *below*. This is also a useful method for cleaning up any smudge marks.

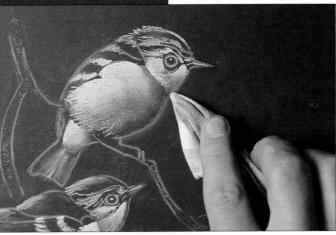

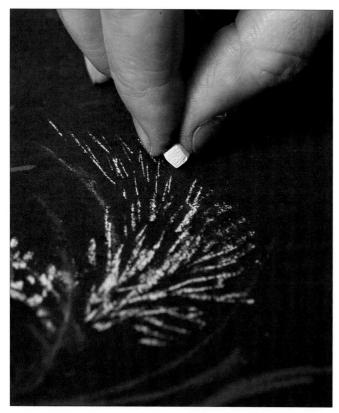

5 The pink flowers need to stand out clearly from the rest of the image, so rather than use a soft blended effect,

stel Techniques

staccato strokes are tapped on using the edge of the pastel.

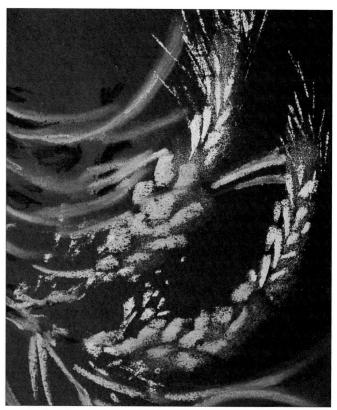

6 Notice how clearly the flowers stand out from the dark background and how well their polleny texture has been suggested.

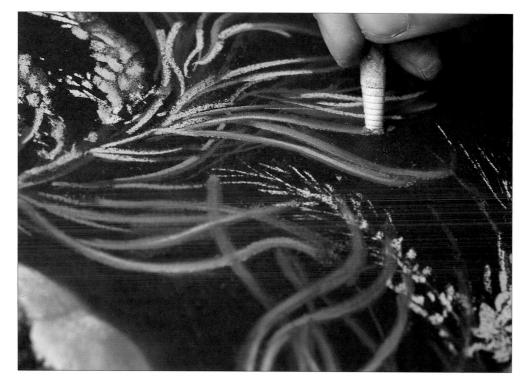

7 I think the artist's method *left* of pulling out the highlights on the pine needles has been most effective. He has dragged the white into the green strokes with a torchon, thus sharply highlighting the needles, which stand out crisply and clearly.

8 The finished pastel *right* illustrates how an extensive use of blending suits the softness of the subject. Care must be taken not to overwork the blending, but I like the way the contours of the flowers have been picked out and the birds' tails given additional crispness by the extra white.

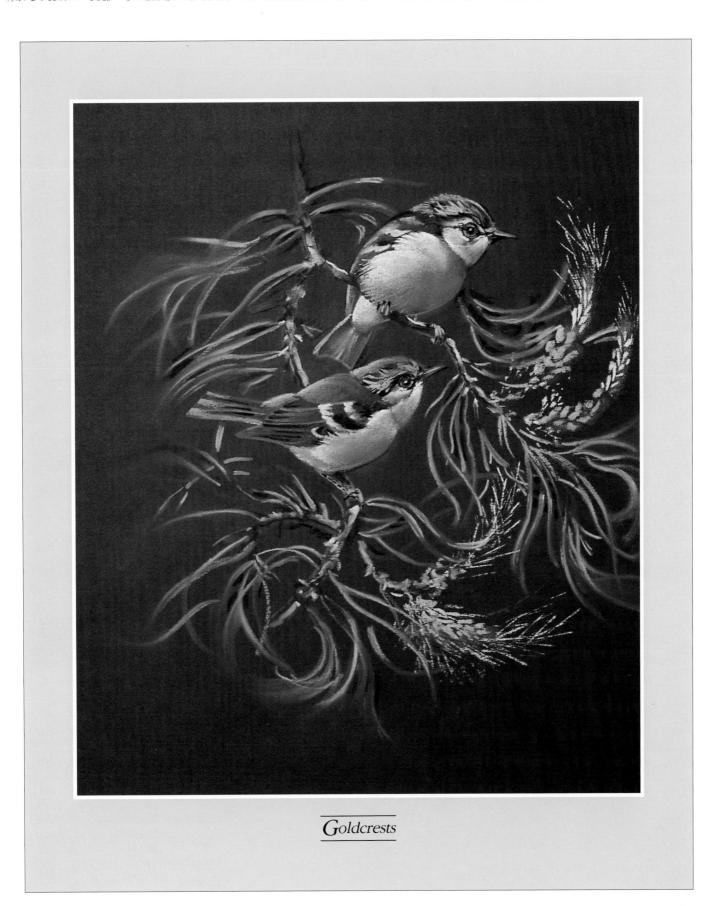

The Racecourse

SOFT PASTELS ON GREEN PAPER

A scene such as this calls for an extensive use of blending to suggest the brilliance of the light effects. Soft rounded pastels were chosen, used on a smooth, pale green paper to help ease the blending process.

Techniques

By holding the pastel full length against the paper and dragging it horizontally across the surface, the artist has managed to avoid sharp contours when describing the shape of the horse. These broad strokes were also used for putting in most of the body, starting first of all with dark gray, black and Indian red. Later, these were overlaid with touches of magenta, light blue, light orange and Naples yellow, so that a wide variety of colors have contributed to the glossy appearance of the animal's coat.

1 Many artists use photographs as a reference or starting point, but notice here how the artist has simplified

the subject to include only what interested him most.

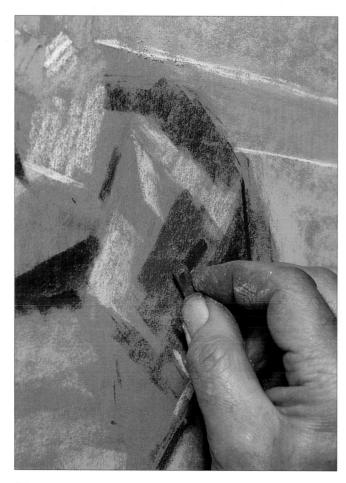

2,3 Although soft pastels have been used effectively here to suggest the velvety turf, it was necessary to bring the main focus – horse, jockey and trainer – forward in sharp contrast. These broad, block-like contours of black *above and left* are a good way of mapping out the shape of the horse's leg.

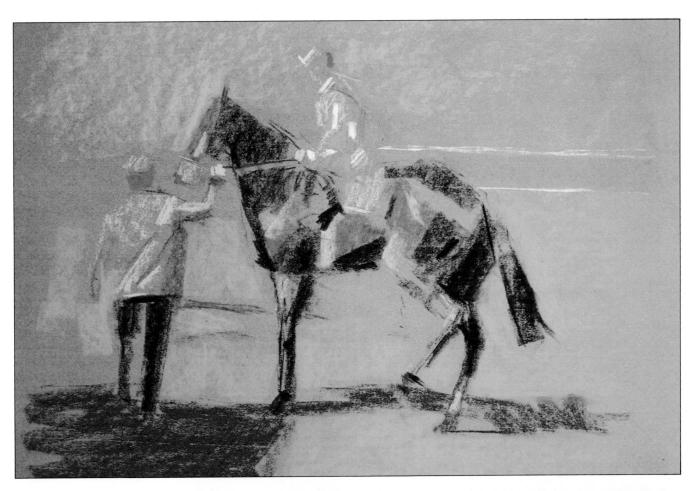

4 I like the variety of textural effects used here. Although the picture *above* is still at the design stage, much of the sleekness of the horse's muscles has already been suggested by picking up highlights of blue and pink on the flanks.

5 A bit more depth is given to the turf by sliding the color across the paper with the side of the pastel *right*.

Pastel Techniques

6 Blending with a finger has helped the artist to emphasize the sleekness of the horse *left*, and I like the way he has used a variety of different colors for the glossy coat.

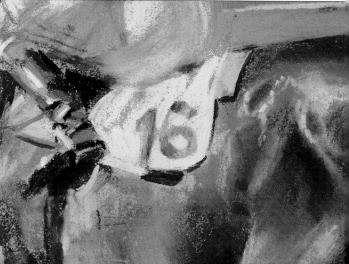

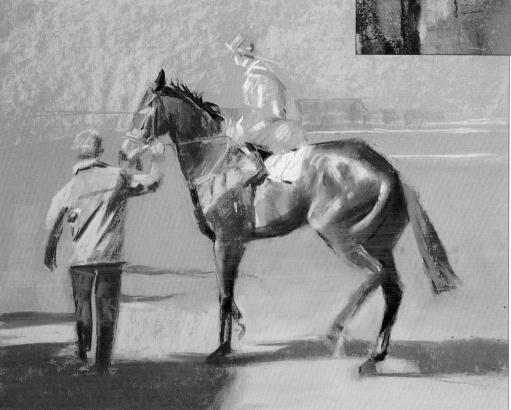

7 This detail *above* shows the careful yet bold treatment of lights and darks to model the shapes. Notice how the deep shadows under the jockey's foot and behind his leg make it stand out in relief from the horse's flank.

8 Already the picture has come to life *left*. The white highlights alone would give a strong impression of sunlight, and the effect is strengthened by the horizontal strokes of black over the turf.

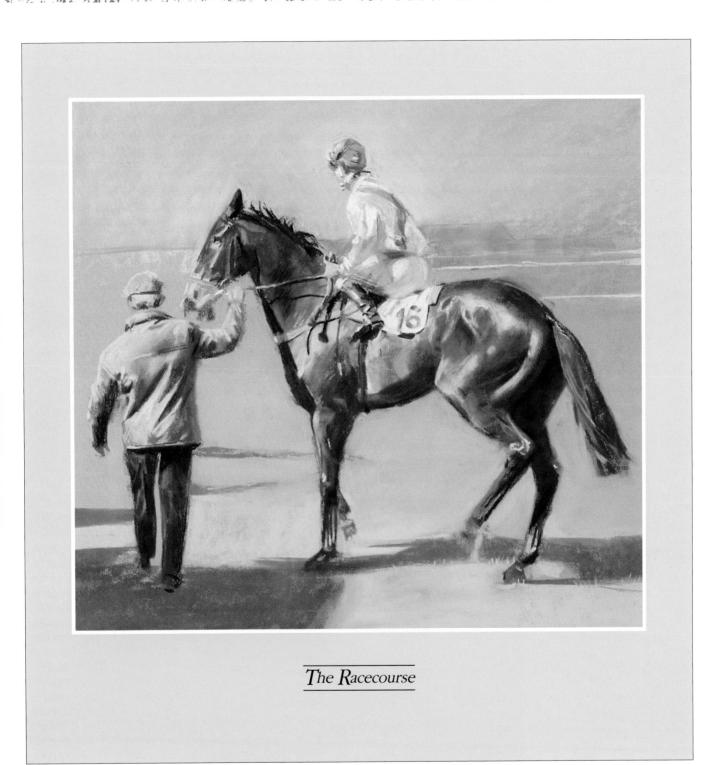

9 The artist has been careful not to overblend, as this would have destroyed the liveliness of his strokes. Even though the subject is rich in detail, there is still plenty of vitality, and the sharp outlines on both jockey and trainer are very successful in suggesting movement.

African Crowned Crane

SOFT PASTELS ON SANDPAPER

The large sweeping strokes used here really express the character of the crane, and the artist has chosen a pose full of movement and drama. He began with a rough outline in Payne's gray, working on sandpaper, which suits a bold direct approach. Next, the span of the wing was described, using a strong stroke with the side of a white pastel, and the basic blue of the body began to take on form.

In the softer areas like the reds and blues of the head and neck, the colors are really pushed in, totally covering the support. As blending is difficult with sandpaper, an impasto technique is essential for solid areas like these. In contrast, the radiating feathers of the crest have been built up from lines drawn with the edge of the pastel and then smudged by sliding the pastel across the sheet. To fix the bird in place, the artist has smoothed the green background around the neck with a hog brush — the danger here, of course, is that the sandpaper surface is so rough, it begins to wear away the brush!

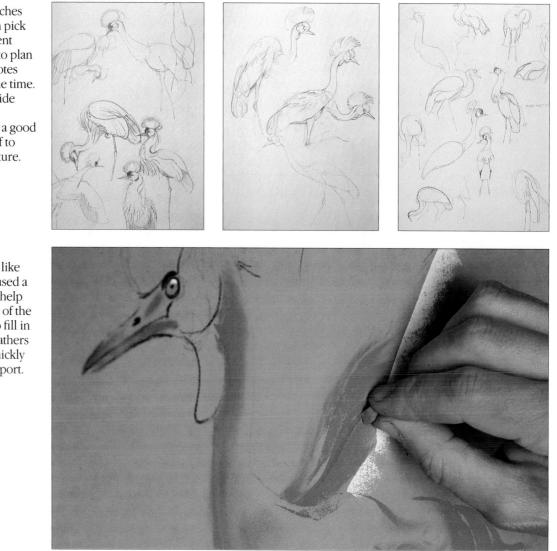

From quick pencil sketches like these, the artist can pick from a variety of different poses when he comes to plan a painting, and color notes can be made at the same time. Sketches not only provide reference material for paintings, they are also a good way of training yourself to observe and record nature.

stel Techniques

1 Accurate drawing is important for a subject like this, and the artist has used a light pencil contour to help him map out the shape of the bird. Here he begins to fill in the main blue of the feathers by pushing the color thickly into the sandpaper support. 2 The sharp stroke of white for the wing bone already gives the feeling of life and movement, and to help him describe the spread of the wing span, the artist uses the side of the pastel to create large sweeping strokes.

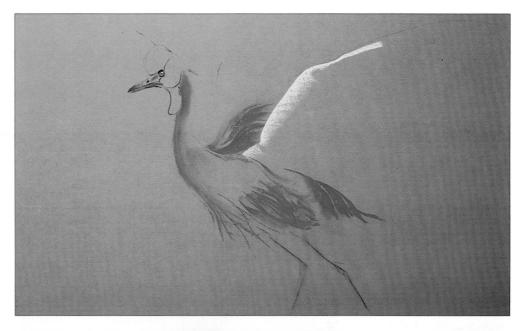

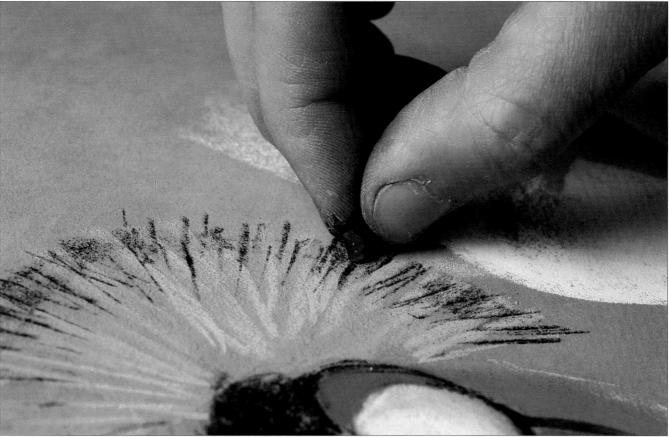

3 The soft feathers of the head are solidly blocked in, and now the artist uses small sharp strokes in pierre noire

to pick out the radiating feathers of the crest.

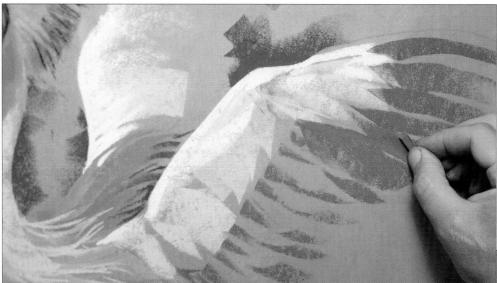

4 Using the flat edge of the chalk *above* is a good way to describe the broader wing feathers. The way the sandpaper support has been allowed to show through the color dragged across it creates interesting textural effects.

stel Techniques

5 Here the artist is using a hog brush *right* to smooth in the green background, an excellent way of emphasizing the bird's sleek neck. However, sandpaper is so rough that the brush could wear away in a very short time!

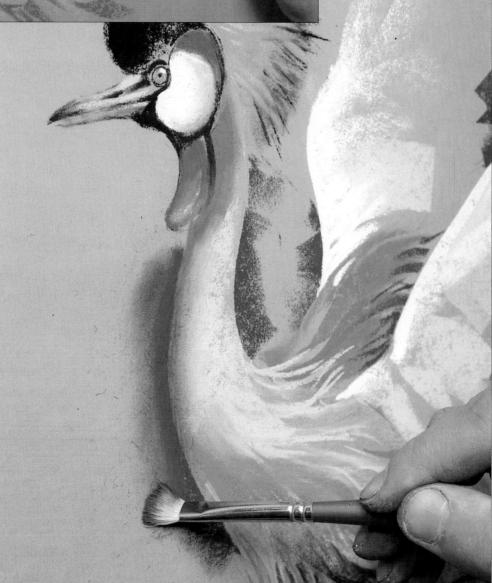

African Crowned Crane

6 The finished pastel shows a lively combination of sharp lines, dense blended areas and light sweeping strokes, all of which are used to suggest the different types of feathers. I also like the way the artist

has left the far wing only lightly indicated, as this helps the impression of spontaneity and movement. Landscape near Castleton

SOFT CONTE PASTELS ON SANDPAPER

Although soft pastels were used here, this landscape has quite a dramatic look which comes from the sandpaper support, on which the artist has applied the pastels in a heavy, almost impasto manner. The support is ideal if you are using bright colors, like those chosen here to suggest the dramatic light effects.

astel Techniques

Working from a general lay-in which determined the composition and spacing, the artist moved to the broader areas like the fields, which he blocked in using the side of the pastel. Once the solid forms had been established, he could then pick out sharp details like branches, shadows and roofs with a pointed scrap of pastel stick.

1 When starting to lay in the composition the artist used thin lines to determine spacing – for example in the horizon and surface of the

road. Vertical strokes, applied quite heavily in parts, have helped him to block in the tree shapes and mass of the hill.

2 Here the artist is going over the blocked-in blue shadows of the trees, using the side of the stick. Quite

rich highlights can be made in this way.

3 Using the side of the pastel allows the artist to spread the green over a fairly large area. Notice he doesn't use

uniform pressure, and in parts the blocking is quite light, so that other colors can be added later. Sharp horizontal lines in sky blue mark out the distant shadows and help to lead the eye back into the picture.

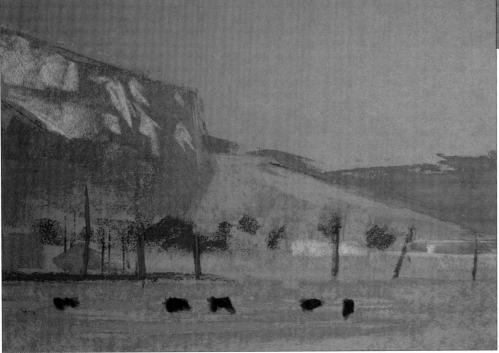

5 The artist has chosen quite solid strokes for the distant hill *left*, but he manages to stop the picture looking too flat by employing lively strokes of light blue on the cliff face.

6 Leaving the strokes less worked in the middle ground gives a more convincing impression of perspective. These hatched strokes act as an ideal contrast to the blocked-in colors in the far distance.

Pastel Techniques

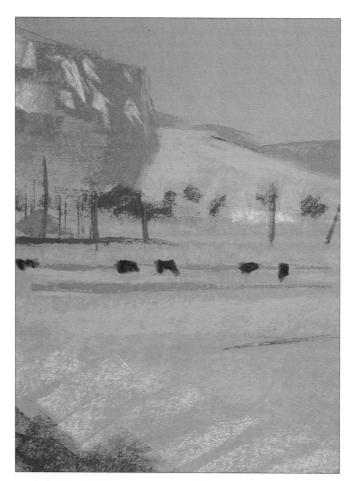

7 The distant shadows are effectively deepened with dark ultramarine *below*. This same intense tone is repeated on parts of the farm buildings.

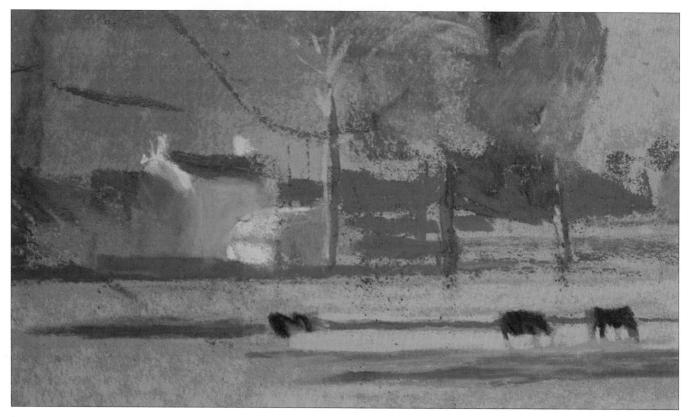

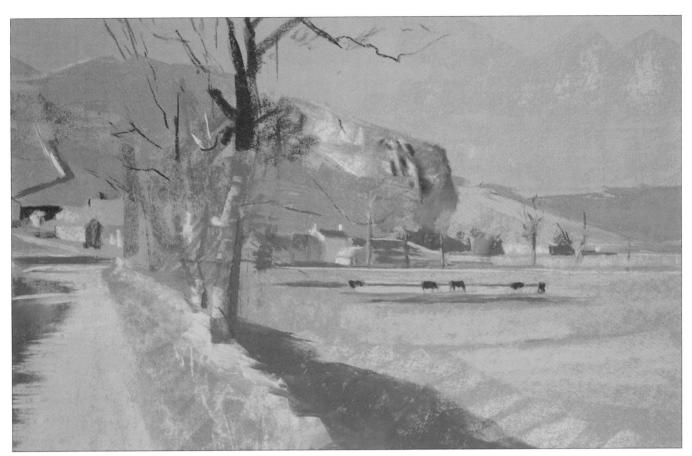

8 I like the use of solid blocks of color here in the foreground. You can't really smudge pastel successfully on

sandpaper, but deep colors can be built up.

9 Now to the details. The artist uses a small but sharp scrap of cream pastel *left* to highlight both the tree-trunk and the house. This is where those broken bits of left-over pastel come in handy!

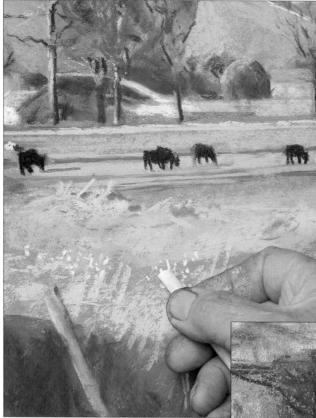

Pastel Techniques

10 Here tiny dots of white are being used *left* to pick out the corn in the foreground, providing an effective contrast to the blended green of the field.

11 I think the use of white highlighting on the wall, branches and road *below* works well; it stops the picture looking too bland, and provides a strong impression of light effects.

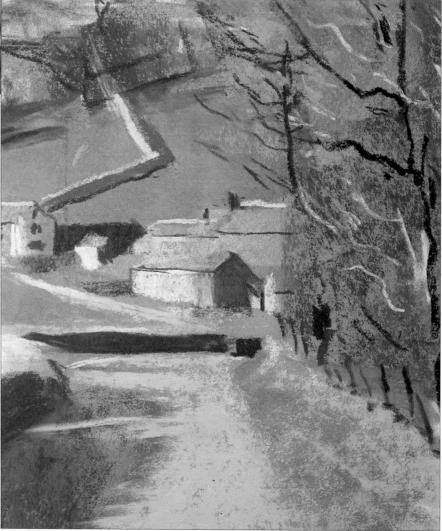

Landscape near Castleton

12 You will see how the fine lines used to suggest the branches and shapes of the buildings help to keep the detail separate from the broader masses of road, hill and sky. The pastels have been used really thick in the

foreground, which contrasts with the lighter touch used in the corn, and also helps to lead the eye back to the distant details.

SOFT PASTELS ON CREAM/IVORY INGRES FABRIANO PAPER

The artist chose a light, warm-toned paper as he found that it suited the natural coloring of the model. Starting with a charcoal pencil, he lightly drew in the position of her head, placing it slightly off-center and on the diagonal, so as to add life and character to the study. Working with soft pastels, he then covered the face with lightly hatched strokes of pink, using a deeper red for the blouse, which he spread and blended to contrast and set off the head.

Notice how the features have been described: a

1 The model was posed carefully, paying special attention to the angle of the head, so that the light areas, the face and neck, balance the dark red of the blouse in a

pleasing way. Getting the pose right is very important in a portrait and it pays to take trouble over it.

charcoal pencil combined with a touch of sky blue gives precision and warmth to the eyes, but the mouth is deliberately left understated to suggest mobility and avoid competing with the eyes. The overall colors of the face are a happy mix of warm and cool ones, and the stronger red of the blouse is allowed to fade out into the tone of the paper to help emphasize the general delicacy of the image.

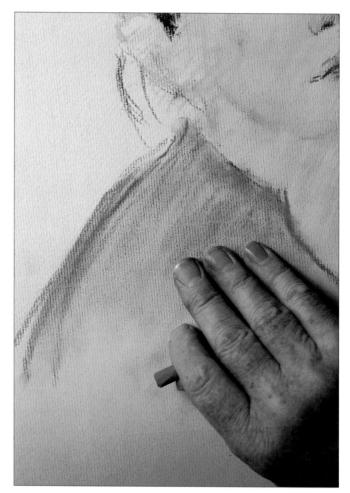

2 I started off by drawing in the outline of the head with charcoal pencil, and this detail shows the face now covered with a warm middle tone into which the features have been lightly indicated. To suggest the softness of the sitter's blouse, I use my whole hand to blend in the red pastel.

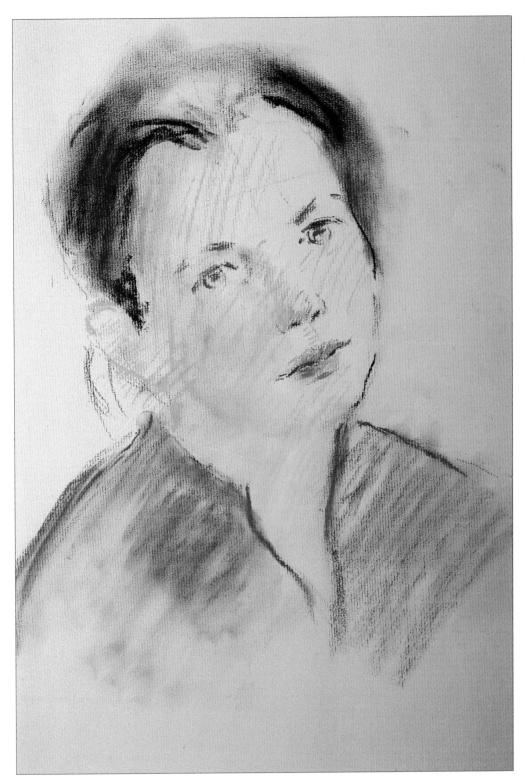

3 Now I have strengthened the tone of the cheek on the shadow side and to provide a contrast to the lightly hatched flesh-colored strokes, I introduced a blue -violet half-tone into the shadow underneath the jaw.

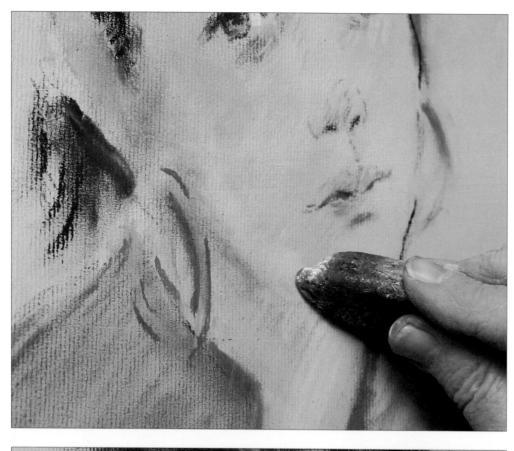

stel Techniques

4 A kneaded eraser helps me to lighten the turn of the jaw above the neck *left*, and also gives the feeling of reflected light. The ear-rings add an interesting design element and help to soften the contour of the face.

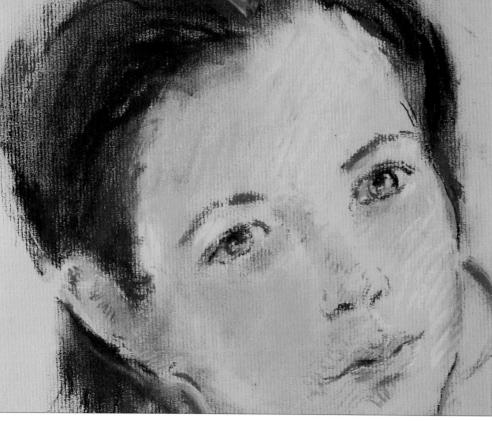

5 Notice how I have left some of the hatching strokes in the face unblended *left* so as not to overwork the subject. Where I have used blending, it helps give the impression of warm tones against the cooler highlights. I haven't colored in the blouse to the edge of the paper; the design is allowed to fade out, letting the imagination do the rest.

6 In the finished painting *right* the mouth is deliberately left understated to suggest mobility and avoid competition with the eyes, which are the focal point in most portraits. Notice the tiny strokes I have used around the nose and underlip: they fit in with the overall lightness of touch and give just an impression of shadows.

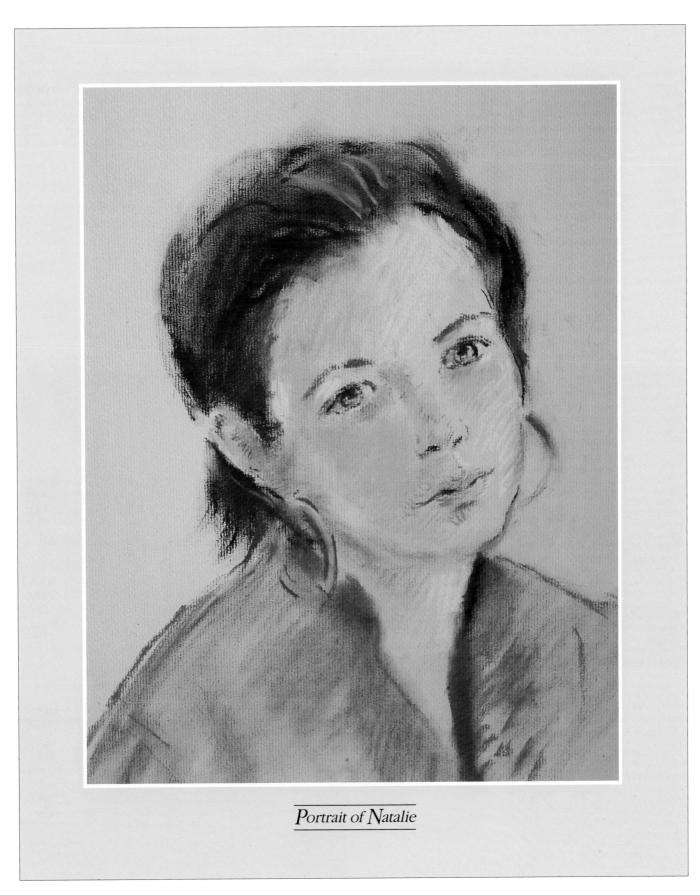

Bullfinches

SOFT PASTEL AND PASTEL PENCILS ON BROWN INGRES PAPER

This is a relatively intricate composition, with the blossom and the birds tightly bound together, and yet the artist has contrived to make the two quite distinct from one another. Using soft powdery pastels which are ideal for suggesting the velvety texture of feathers, he used the side of the stick to drag color onto the breasts and heads of the birds. Depending on the size of the area you are working with, soft pastels can either be finger-blended or — for finer edges — blended with a torchon or bristle brush, both of which have been used for the heads of the birds and also for the leaves.

astel Techniques

Obviously, such soft pastels are less appropriate

for sharp detail, so the artist wisely changed to pastel pencils for these, also taking the opportunity to redefine the birds' contours so that the image began to take on a sharp brilliance. Notice how the blended areas are kept alive by varying the strength of blending: the petals of the blossom, for instance, are only lightly blended and the artist has allowed the grain of the support to show through.

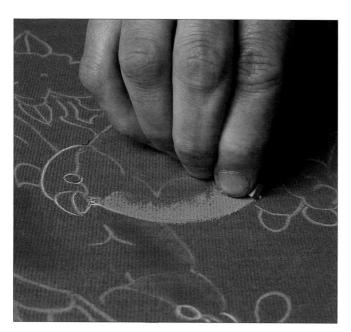

1 The best way of approaching an intricate composition such as this is to start off by marking out the design in pastel pencil *above*. Pencils give you a very controlled contour, and here the artist has used white, so that the image stands out from the gray tone of his support. 2 A stiff hog's hair brush is being used *right* to work in the powdery black pastel used for the head of the bullfinch. The soft pastels are a good choice, as their texture resembles the velvety feathers.

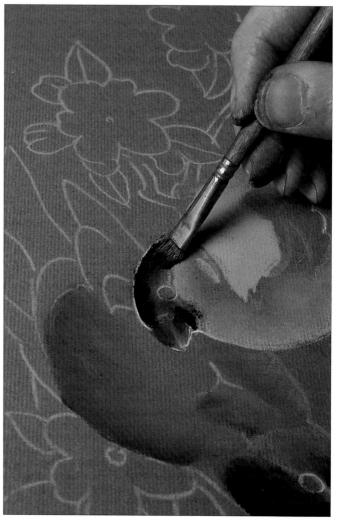

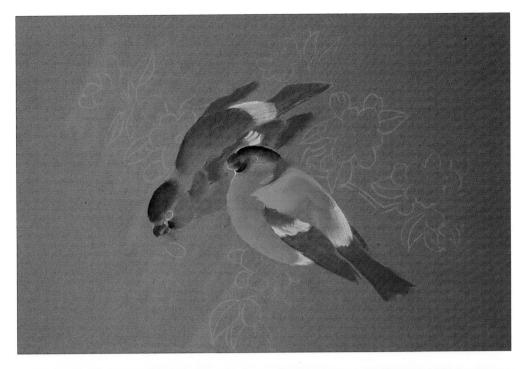

Quite a lot of blending has been used by this stage *left*, so the artist needs to pull out details like the tips of the birds' tails, using sharp white pastel pencil strokes.

4 The artist has brought a feeling of life into the composition *below* by only marginally blending the petals of the flowers and letting the grain of the support show through. This makes a link between the flowers and the white markings on the birds, and also helps to make the velvety parts of the birds' bodies look convincing.

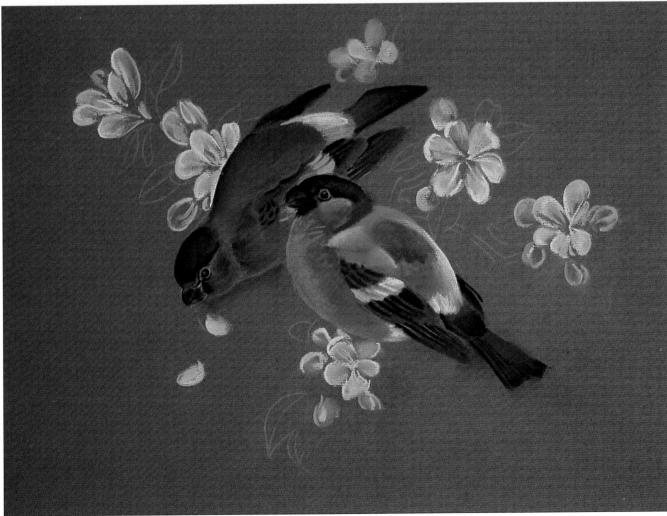

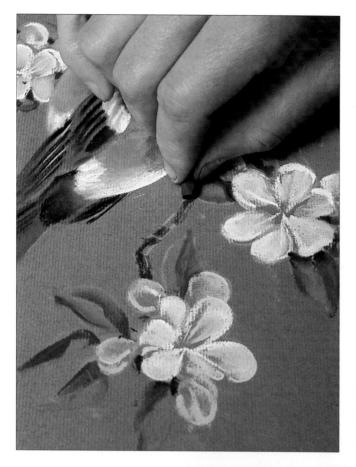

5 To enhance the feeling of liveliness, the artist is employing a technique known as lost and found for the branches *left*. Very lightly, he drags a soft black pastel into the contour, which helps re-create the rough, woody nature of the branch.

6 Obviously some parts of the foliage need blending to give a convincing textural effect, particularly the shadows underneath the leaves. Given the small area he has to work in, the artist wisely uses a torchon *below*, which gives him very accurate control over the pastel.

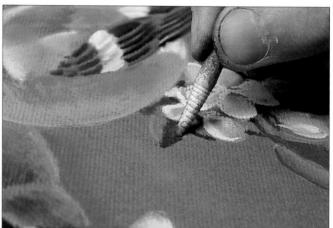

7 Highlights on the leaves *right* are sharpened in lime green, using the point of a pastel.

astel Techniques

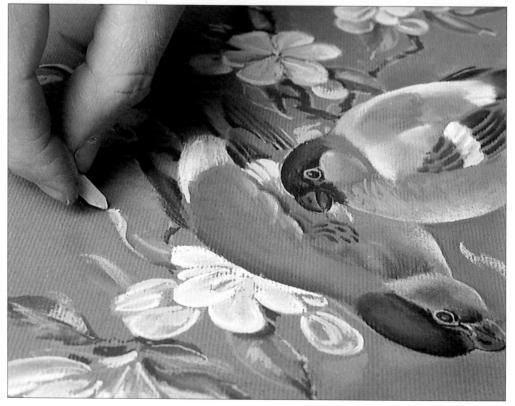

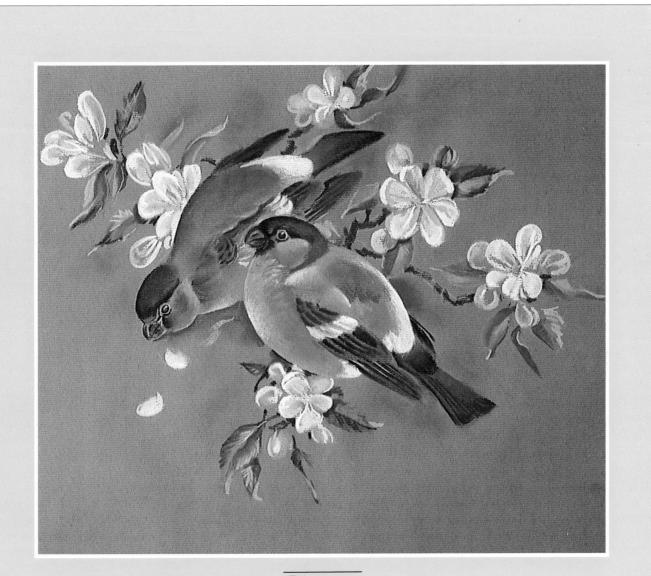

1.217

8 The finished painting shows a very varied combination of strokes in spite of the powdery nature of the pastels used. The mass of the birds' bodies in their

blended form stands out, with the crisp contours on the petals mapping out a different but equally lively texture. Study of the Artist's Hand

CONTE PASTEL PENCILS ON WATERCOLOR PAPER

A rich effect like that of Old Master drawings can easily be achieved by using pastel pencils in browns and grays. Here the artist has chosen his own hand as his subject, starting by mapping out its shape with a sanguine pencil. At this stage, any wrong lines can be left in as a guide to help establish correct ones, whereas rubbing them out could simply lead you to

Notice how once the shape has been laid in, the artist moves to the softer fleshy areas, using a lightly hatched stroke to mark out the parts in shadow. It then only needed a torchon to smudge the strokes into a resemblance of flesh and bone.

1 Here the artist uses a conté sanguine pastel pencil to map out the contour of the hand.

astel Techniques

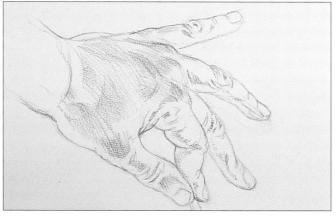

2 You can get marvelously soft effects with these pencils, so he is able to fill in the folds, wrinkles and form of

the hand immediately by using a variety of lightly hatched strokes.

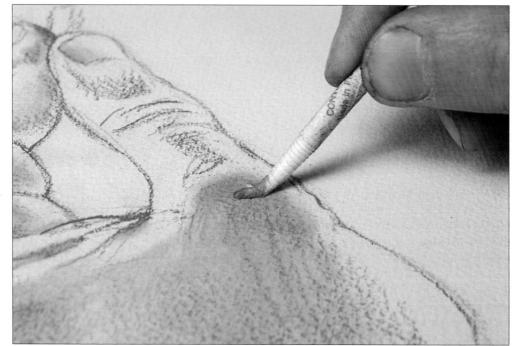

3 Because of the position of the hand, the darkest part lies around the knuckles. These have been given a very convincing look of flesh in shadow *left* by using a torchon to blend the color into the paper. **4** The position is established, and the shadows worked out, so now the artist tackles the contours *right* to help strengthen the image and match them to the density of the blended areas.

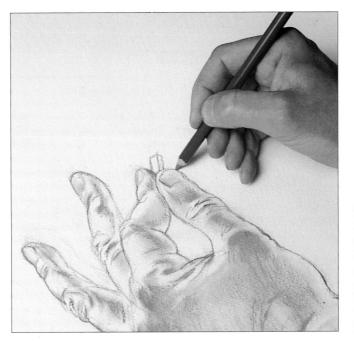

5 I like the way the artist has stopped the hand from appearing to float in mid-air by emphasizing the points of contact with a black conté crayon *below*, which has also been used on the knuckles to "pull out" the form of the hand.

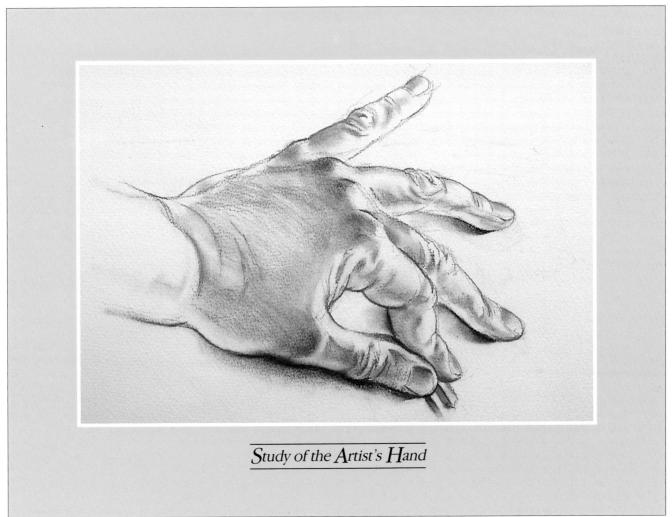

Elephant Running

SOFT AND HARD PASTELS ON DARK BROWN MATTING BOARD

The artist made several charcoal sketches at the zoo, paying special attention to the way the elephant's hide folded as it moved, which he needed to understand fully before he embarked on the painting. He chose a dark brown matting board for his support for two reasons: not only does the tone complement the subject, but its smooth surface does not create too much dust, and therefore colors are not so easily smudged.

The main dark and light areas were blocked in with broad-edged strokes, which were then "dragged" with a torchon to blend them into the background color. A wide variety of blending methods has been used: a small piece of bread, kneaded into a ball of dough, helped with picking out the highlights on the elephant's ears; harsh contours were softened with a finger, and a rag was used to smooth and blend the broader areas of the body. Care had to be taken not to blend too much, or the shape of the elephant would have become too soft and rounded, so the artist defined areas such as the shadow under the ear heavily in black. In other places, loose, scribbled strokes give the impression of the wrinkled, leathery hide, and sharper details in the foliage and animal's head have been picked out with pastel pencils.

1 Working from life, the artist started off by making a charcoal sketch of the elephant at the zoo. As can be seen, one of his main interests was in the way the flesh and hide folded as the animal moved.

astel Techniques

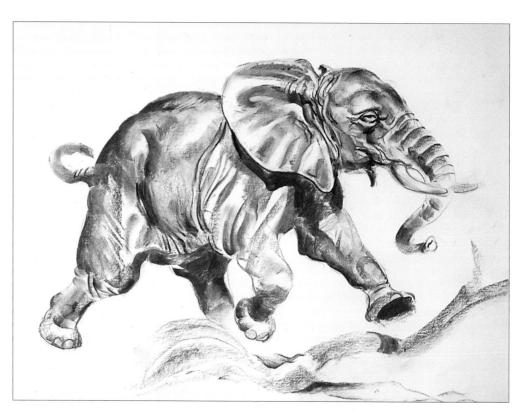

2 Using the sketch as his source of reference, the artist starts by blocking in the main light areas, and working from dark to light in broad strokes. He now draws the edge of the

pastel across the head so that the dark colors can blend lightly.

3 The artist has used several different methods for blending and lightening areas. Here a small piece of kneaded bread is being used to pick out highlights.

4 The next stage *left* involves blending the light colors. Using a torchon, the artist drags the color toward the white chalk outlines. This successfully creates the gray, rather leathery look of the elephant's hide.

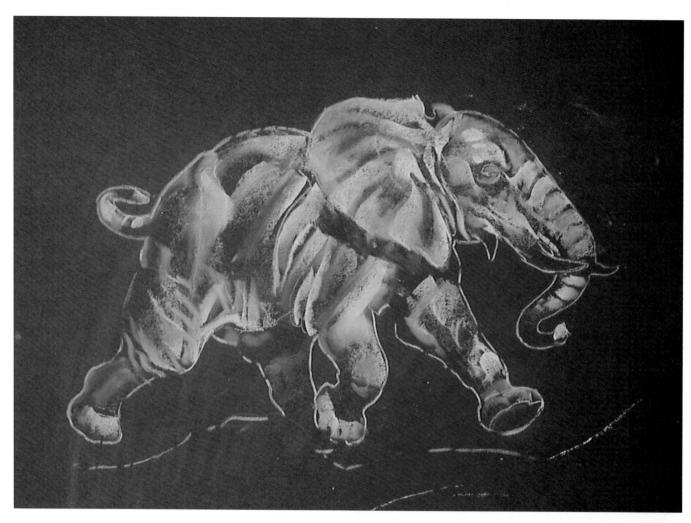

5 The white chalk contours are still present *above*, but the blending has helped not only to give form and bulk to the body but to provide an impression of movement, particularly where the artist has used it extensively around the flanks.

astel Techniques

6 Harsh edges of some strokes can be softened with a finger, but for broader masses like the body, a rag has been used *right* to soften them even further.

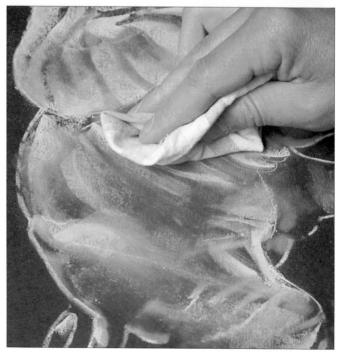

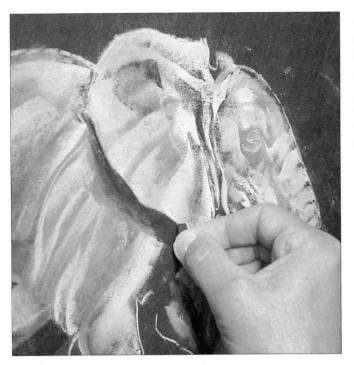

7 The shape of the animal could be lost if blending were to be taken too far, so the artist re-establishes the form *left* by drawing quite heavily in black around the underpart of the ear. This gives some "bite" to the shadow areas.

8 I like the way the intense black under the ear succeeds in lifting it away from the body *below*, thus intensifying the feeling of movement. The dark hide stands out well in contrast to the sharp white used on the tusks.

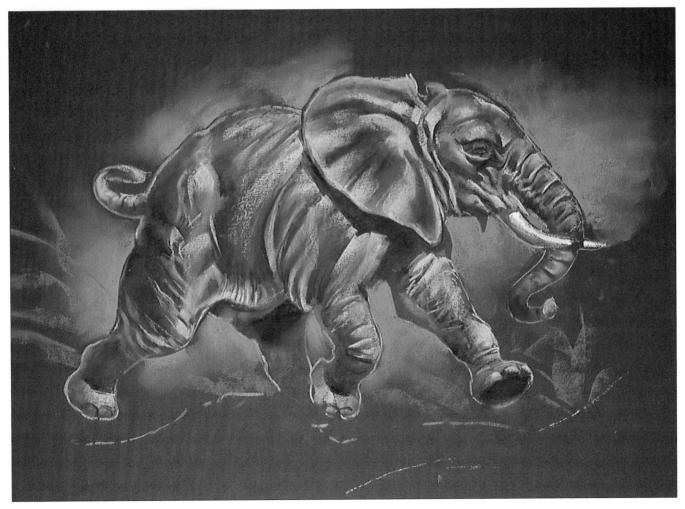

9 A bit of warm flesh tone has been added to the tusk, which is a good idea, as pure white highlight would have looked too harsh. Here the artist is using cobalt blue *right* for the background, drawing the color up to the edges of the elephant to make the animal stand out, and then blending it with a finger.

astel Techniques

10 The artist has now begun to indicate the foliage in bluegreen and St Michael's green *below*, quite loosely described at this stage. I like the way those scribbled strokes around the trunk and legs stand out from the more broadly blended areas, and strengthen the impression of wrinkled hide.

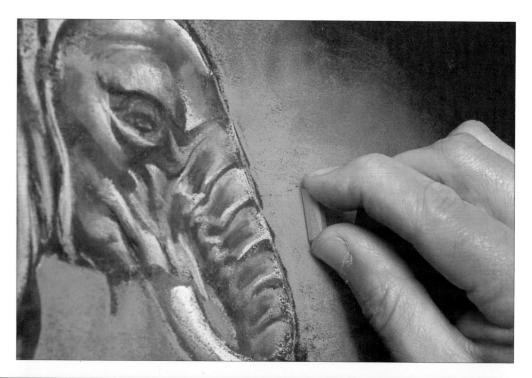

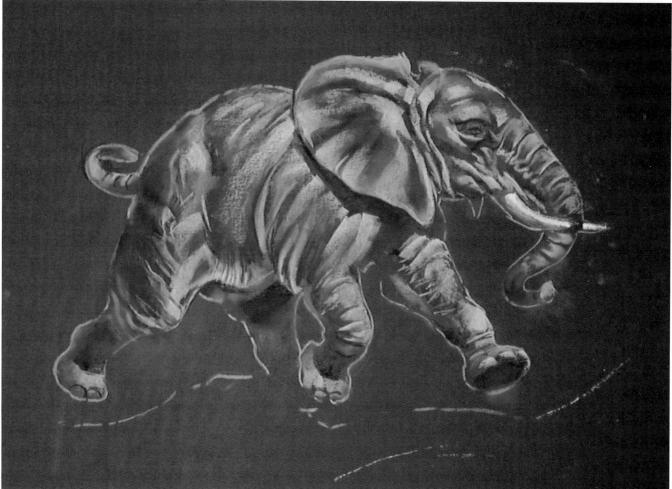



Elephant Running

11 The final effect might be thought a little overworked perhaps, but it was a good move to lighten the intense blue background with touches of turquoise and white. I also like the way the foliage overlaps the hind legs

to give contrast in texture and add a feeling of depth. The treatment of the branch in the foreground is very similar to that of the body, which gives a unity to the whole picture.

SOFT PASTELS ON GREEN-GRAY INGRES PAPER

With portraits, it is always a good idea to choose a slightly tinted paper which will complement the coloring of your sitter. Here the artist picked a green/gray Ingres paper which blends well with the sitter's hair and the blue shawl. He began by emphasizing the modeling of the face in planes of soft color, and in the shadows of her hair, he has used a greenish-gray tone which blends in well with the paper and helps to pull the lighter tones of her face forward.

To model the face and give it a feeling of liveliness, the artist used an extensive range of flesh-colored tones — light orange, Naples yellow, gray green and pink — and has left them unblended, so that the color itself actually models the shape of the head. With head and shoulder studies like these, it is much better to play down details in the sitter's clothes, as the face is the focal point. The flowers on her shawl are only just indicated, and the color of the blouse is allowed to fade into the tone of the paper. Blending was used solely on the shawl, to tone down the blue.

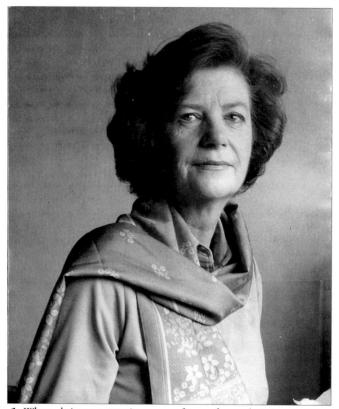

1 When doing a portrait from life, it is most important to make sure your model is comfortable. Photographs can provide a useful back-up if the model cannot spare time

for prolonged sittings or needs to take frequent rests.

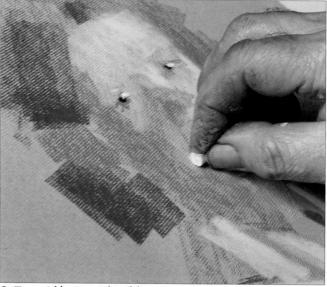

2 To avoid losing sight of the form and position of the sitter's head, the artist has started off by making a broad lay-in of color for both the hair and face. Over this he is dragging in some flesh tones to suggest the highlights of her face.

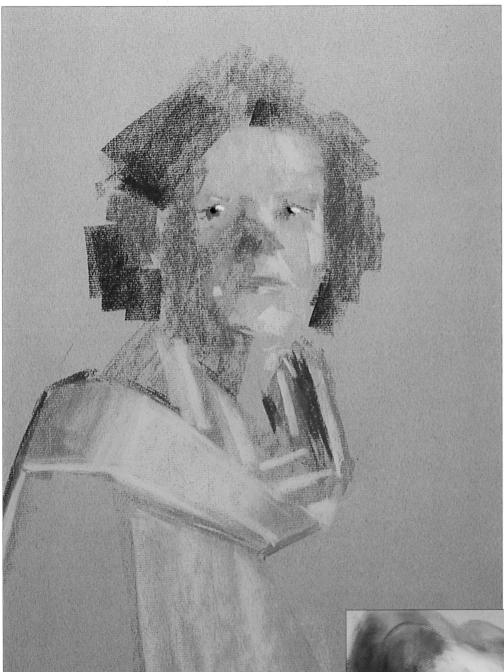

3 The portrait looks almost Cubist at this stage, but already there is a feeling of likeness, especially in the way he has captured the liveliness of the sitter's eyes. I like the way he uses much sharper contours in cobalt blue around the edge of her shawl; this helps pull the body forward and set the head in position.

4 In this detail *below*, you can see the wide range of flesh tones the artist has used to give life to the face — light orange, Naples yellow, gray, green and pink. All of these have been left unfused so that they form facets which actually model the shape of the head. Here the artist is adding a small stroke of white across the lower lip which effectively pulls the mouth forward.

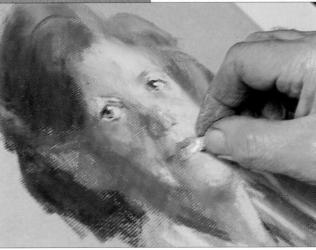

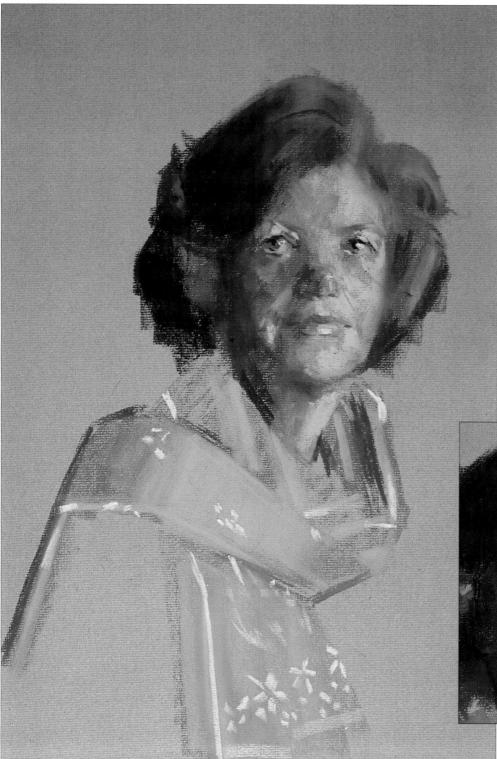

5,6 A touch of sky blue in the whites of the eyes below links up to the color of the sitter's shawl. This is much better than using pure white, which would make the eyes appear too dominant and would not really be true to nature. I like the way the hair is only broadly indicated, as this lets the viewer concentrate on the rest of the head. Similarly, the artist has really only hinted at the blouse and shawl left, with the pattern of flowers being deliberately played down to avoid competing with the face for attention. Notice too, how the gray-green support has been left showing through in large areas, adding tone to the composition and mixing well with the colors used.

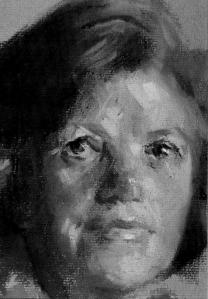

7 In the finished pastel *right* the edges of the face are still very soft although considerable tonal contrast has been used, and no hard contours appear anywhere. Instead, the whole face has been built up through color.

astel Techniques

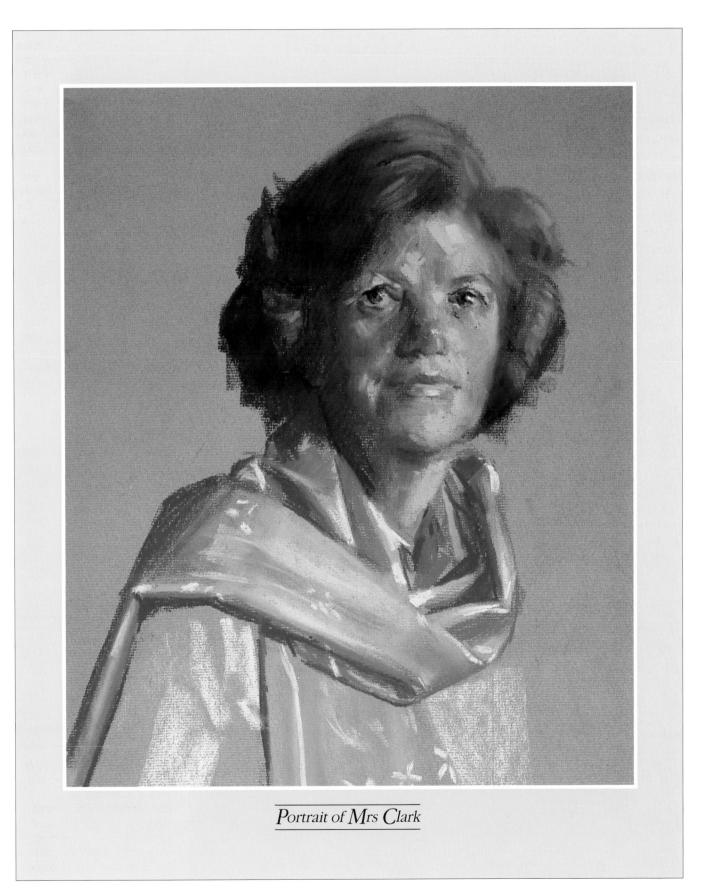

Raccoon

SOFT CONTE PASTELS ON SANDPAPER

Sandpaper, which enables an exciting range of textural strokes, provides an ideal support for animal subjects. Here the artist has laid in the head and body of the raccoon with broad, even strokes, using the flat edge of a soft pastel, and already the pastels begin to pick up the grainy texture of the support, giving a pleasingly lively effect. Brushes and torchons have both been used to blend in the softer areas of the fur, such as the tail and breast — notice how the tail is made up of broad bands of dark gray and burnt umber which have literally been pushed into the surface. It should be borne in mind that sandpaper will only hold a certain amount of pastel before clogging up, though more colors can be added if each layer is fixed beforehand.

astel Techniques

To help sharpen up the shapes and differentiate the animal itself from the foliage, the artist has added bold thin strokes in white conté pastel pencil to certain areas, for example the guard hairs, eyes and contours of the ears. The foliage, described in dark olive green and St Michael green, adds an interesting color note, as well as placing the animal in context by suggesting its natural environment.

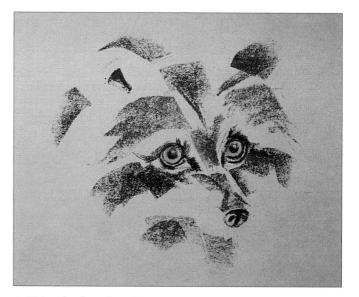

1 Using the flat edge of a crayon, the artist maps out the shape of the head in broad, even strokes. At this stage, the colors are limited to black, gray and Indian red for the eyes.

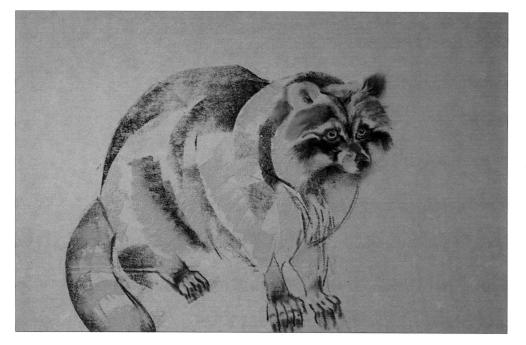

2 The light parts of the fur appear almost blue in places, so using a soft pastel, the artist has put in loose, broad strokes of blue-gray. The body is already beginning to take shape; although there is the minimum of contour, there is just enough to position the animal.

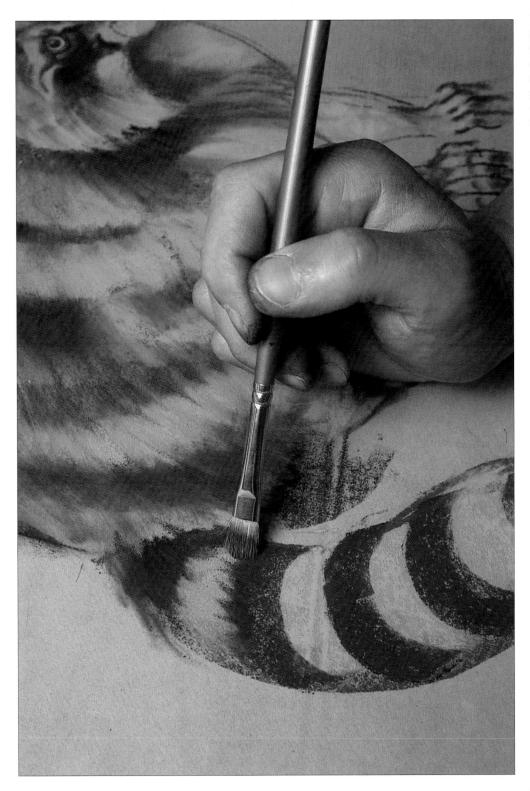

2.4.22

1.277

6

L'A

41

3 Using a small bristle brush, the artist begins to blend the colors into the sandpaper support, a good way of getting rid of those hard edges and suggesting the soft roundness of the animal.

T

4 Here a torchon is being used for dragging color into the fur, which helps to model the tail. Torchons are not ideal for use on a rough surface, as there is a danger of them breaking down; a brush is really much better.

stel Techniques

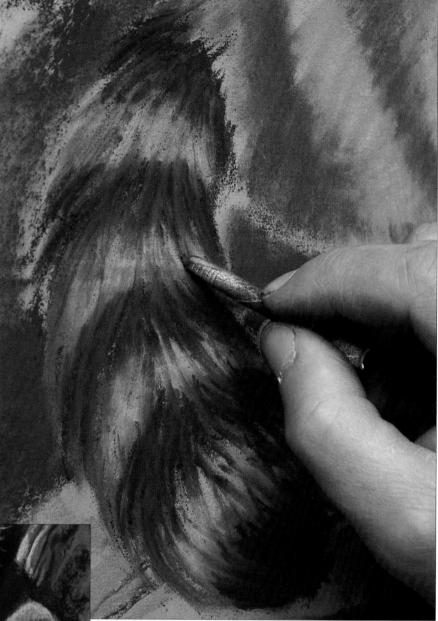

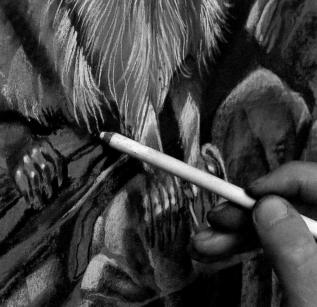

5 With too much blending the animal could end up looking too soft and blurred, which wouldn't suit its nature! One way of bringing out details against those more densely worked areas is to go over the surface with thin white pencil strokes *left*, here used to describe the long, sinuous guard hairs.

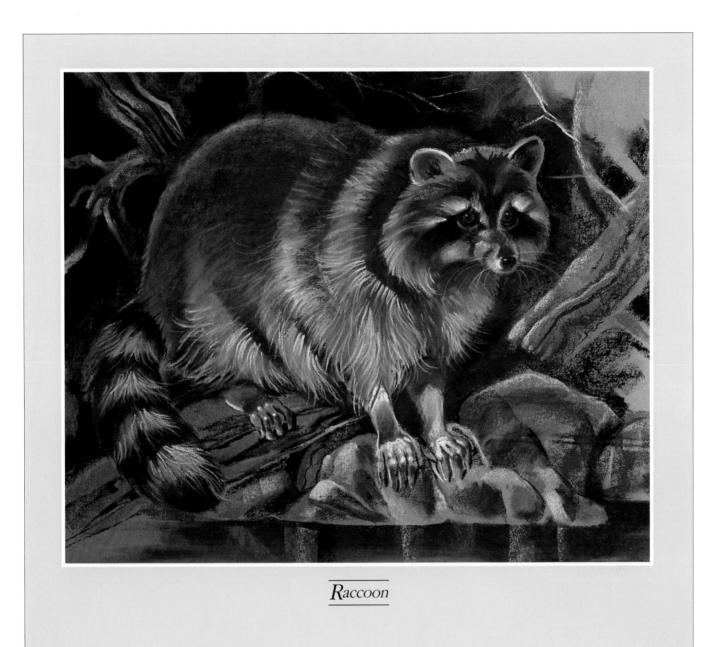

6 There is quite a lot of foliage and undergrowth in the picture, and care had to be taken not to lose the animal in so much detail. The halo of St Michael's green around the animal's body has been used to isolate it from the background, and the

same tone has been used to pick out the branches and some of the foreground boulders. This provides a counterpoint to the warm Indian red which has been used on the raccoon's back. Still Life with Fruit

SOFT CONTE PASTELS AND PASTEL PENCILS ON GREEN/GRAY INGRES FABRIANO PAPER

A modern graphic look has been given to this traditional still-life subject by using a combination of soft pastels and pastel pencils in finely hatched strokes. The artist started by roughing in the shape of the fruit with appropriately colored pencils, and then blocked in areas of color. Each shape is modelled in a variety of tones, with light cross-hatching in white used to highlight certain areas and give a fresh, sparkling look to the fruit. In places, small patches of the gray paper have been allowed to show through also, which adds to the surface interest.

Technique

Notice the successful use of warm and cool colors: by placing the melon and strawberries against the intense blue background, the strawberries appear to be "pulled" into the foreground, with the cooler blue appearing to recede slightly. Color has also been used to emphasize the form of the fruit, and even the shadows contain several colors. The background window has been left as a rather neutral gray, in order not to compete with the brilliance of the foreground, but it reads perfectly well as a window, and the artist has suggested the glass by making loose, overlapping strokes.

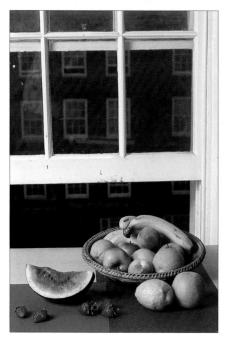

1 The photograph shows how the artist has selected and simplified, lightening the tones in the background and treating it in a much more generalized way.

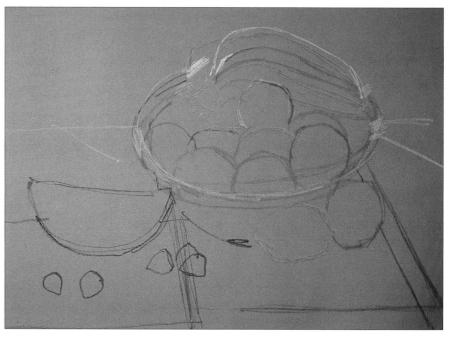

2 The artist has roughed in the positions of the various objects by drawing light contours in the appropriate colors. Once the general design has been established, he can begin to block in with color.

3 The strokes used *right* are left unblended and give a good, crisp, graphic look to the subject which I think is most effective. Notice how the artist begins to build up shadow areas and texture on the blue ground by creating a web of cross-hatching in parts of the picture.

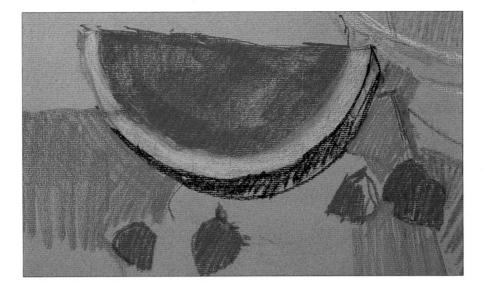

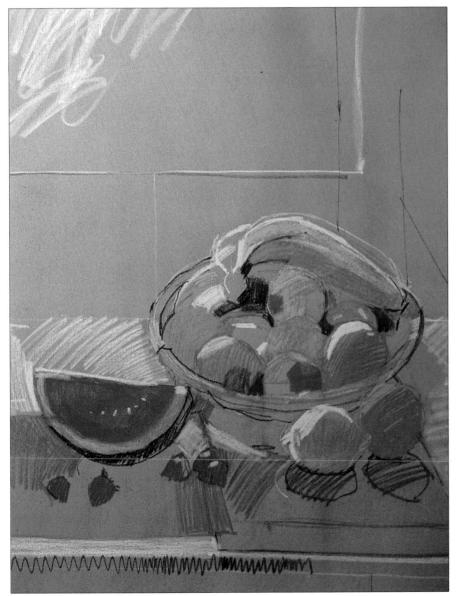

4 The artist has indicated the fall of light with bold blocks of white pastel *left* set along the fruit and table edge, a good way of marking out highlights before getting too involved in color and detail.

5 Because he has kept his initial coloring-in lightly hatched, the artist can now overlap with other tones so that the forms of the fruit begin to emerge. The watermelon looks suitably succulent, and the addition of thin white strokes suggest its crisp texture.

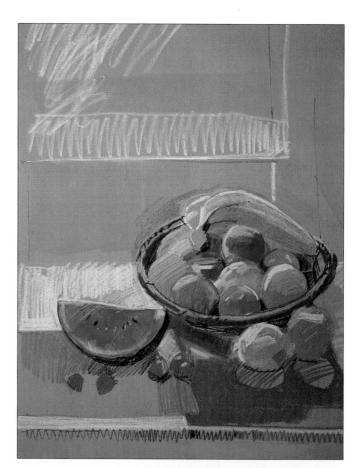

6 Now to the table top — put in quite solidly with olive green, over which light squiggly strokes of lime green have been used for the shadow areas.

astel Techniques

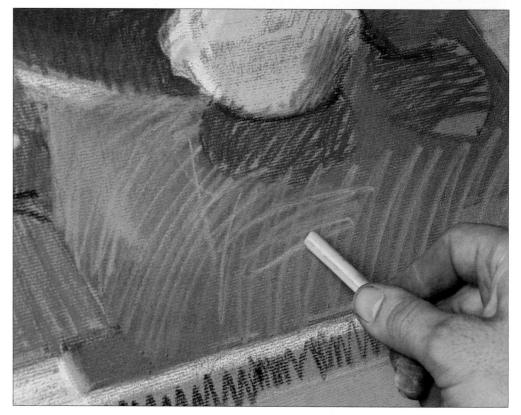

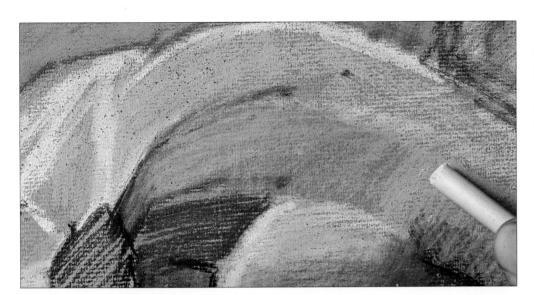

7 The banana is made up of a variety of light and darker yellow tones which suggest the planes of the fruit quite clearly, but without the use of hard-edged contour. The orange tone on the underside of the banana harmonizes well with the neighboring apple.

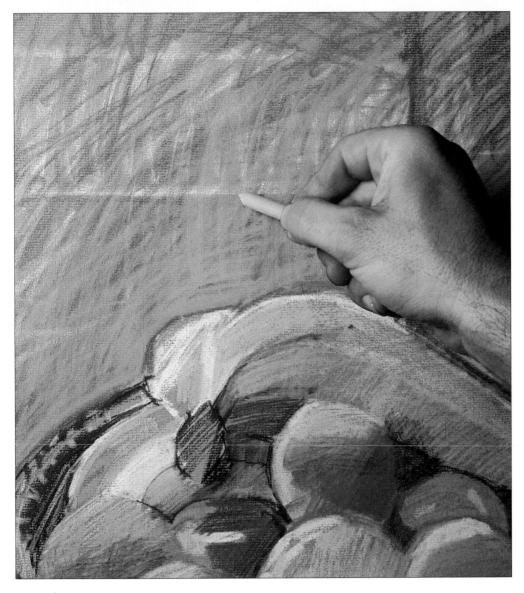

8 It is difficult to suggest the transparency of glass, but here the artist has found a successful compromise. He has built up a loose web of overlapping hatched strokes in gray, white and black which suggests the shine on the glass window, and the choice of such a neutral color combination allows the eye to concentrate on the brilliance of the fruit.

9 More color effects achieved here through crosshatching. Those thin green strokes on the lemon manage both to enhance the form and to pick up the colors of the shadow areas. The strokes are kept quite loose, which I think is good, as it suggests the shifting movement of light more effectively.

astel Techniques

10 The artist has allowed some of the gray support to show through, which I think enhances the liveliness and textural look of the watermelon. Notice how he achieves tones and shadows by overlapping cross-hatched strokes of light over dark blue in the foreground.

11 In the finished picture *right*, the tones, colors and textures are nicely balanced, with just the right amount of interest in the background. Placing the red and yellow fruit against the green and blue of the table top has succeeded in pushing the fruit into prominence and strengthening their colors, while the quiet gray of the background recedes to its proper place.

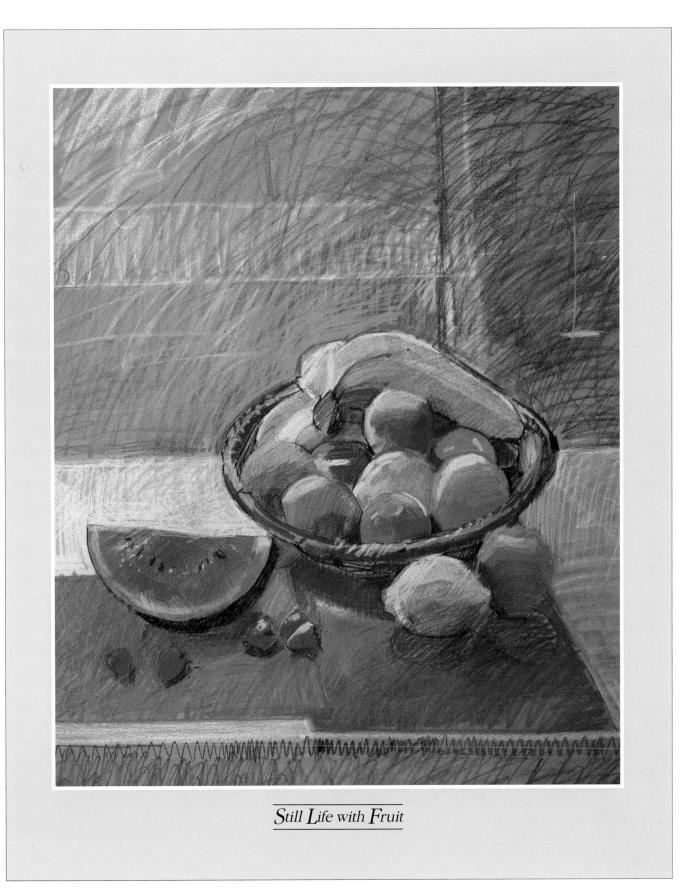

The Alhambra

ART PASTEL CONTE PENCILS ON OIL-SKETCHING PAPER

Pastel has to be the most versatile medium for creating unusual and interesting stroke effects, and in this example we see how the artist has used a form of stippling, or pointillism, to illustrate the dappled play of light around the palace's interior. Stippling is best achieved with either pastel pencils or oil pastels, as soft pastels tend to smudge too easily. Even so, the artist had to hold the pencils high so as not to smudge already worked areas, which has also helped give a loose and spontaneous effect to the picture. Notice how she has varied the size of these dots to stop the picture looking dead. For the foliage, she has chosen a tight, closely worked effect, while to add a touch of variety and strength, parallel cross-hatched strokes in pink and blue have been used to describe the curved arches.

astel Techniques

1 The artist has chosen to work in a whole variety of stippled strokes to suggest dappled light. Notice how she uses sharper, vertical lines of

cobalt blue along the contour of the pillar to give definition to its shape.

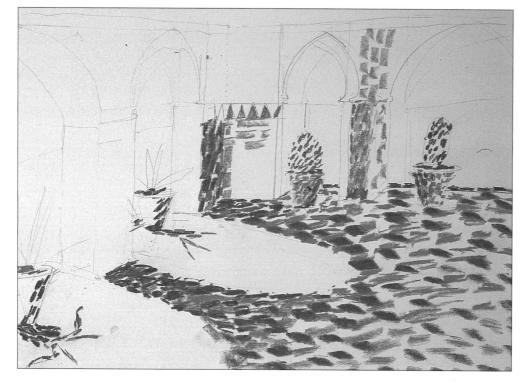

2 The composition is more or less mapped out at this stage *left*. The artist has used a pastel pencil to pick out the shape of the arches and there is an interesting, almost pointillist use of juxtaposed ultramarine and cobalt blue, which I feel successfully marks out the shadow areas, without in any way looking lifeless.

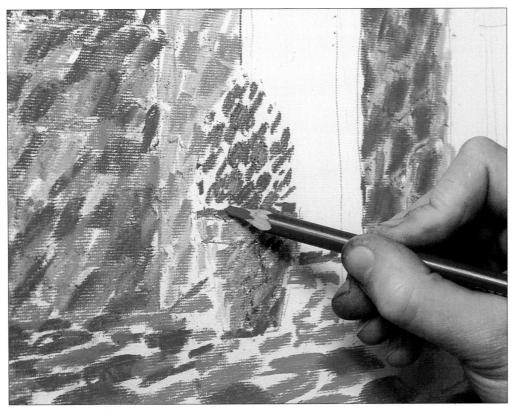

3 Using an Othello flesh tint in a similarly stippled manner *left* gives a very good impression of sparkling light. There is a danger that the lively pattern created could overwhelm the subject, so the artist is re-defining the shape of the tub with cobalt blue pencil.

4 That same flesh tint is used most effectively *below* over the surface of the floor, first on its own to suggest the flood of light through the arches, and secondly as a light stippled note throughout the shadow areas. In contrast, loosely hatched strokes have been used under the curve of the arch, giving a strong sense of form.

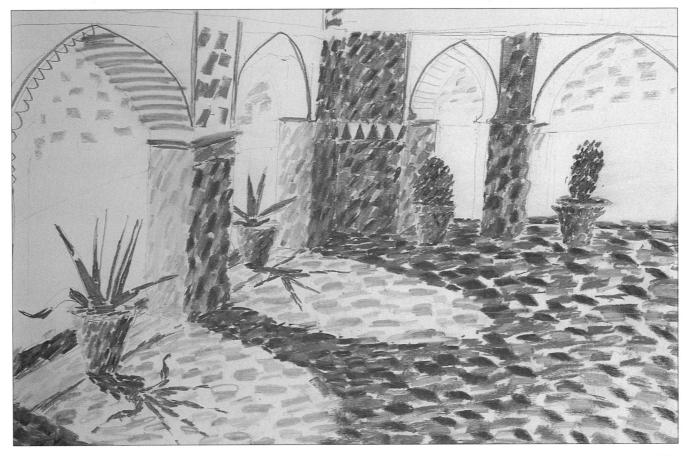

5 This detail shows the effects you can achieve by combining hatching strokes in different colored pastel pencils. The colors match the stippling on the walls, but hatching strokes give clearer definition to the shape of the arch. The artist is holding the pencil deliberately high in order not to smudge the work and to help keep the hatching loose and flexible.

astel Techniques

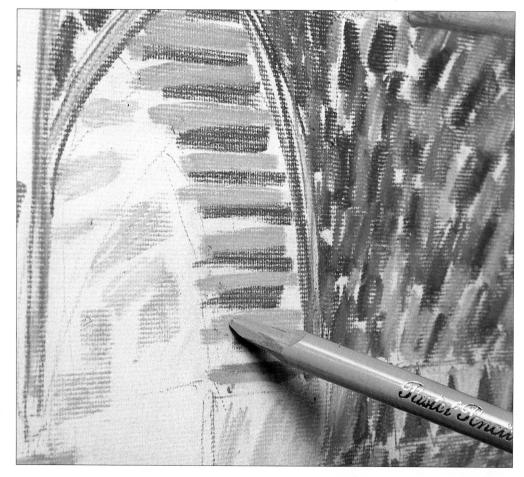

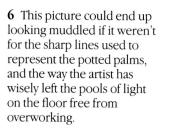

7 The sky outside is given much the same stippled treatment *right*, but its lighter hue stops the image from looking too busy. The graygreen and blue dots in the background give a good impression of distant trees and help to differentiate the landscape outside from the stronger blocks of stippling the artist has used in the foreground. She has blended the sky area in parts with a rag to give a soft, cloudy effect, but it's good she hasn't overdone this.

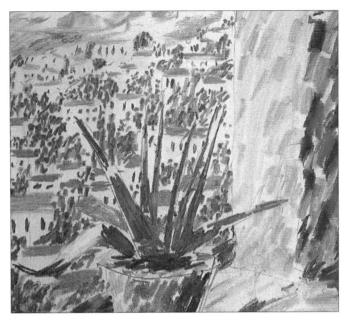

8 The finished pastel *below* has a delightful sparkle, and the whole picture is vibrantly alive. In spite of the similarity of the strokes used, there is no problem in separating the interior and exterior areas because of the stronger colors and greater tonal contrasts in the foreground.

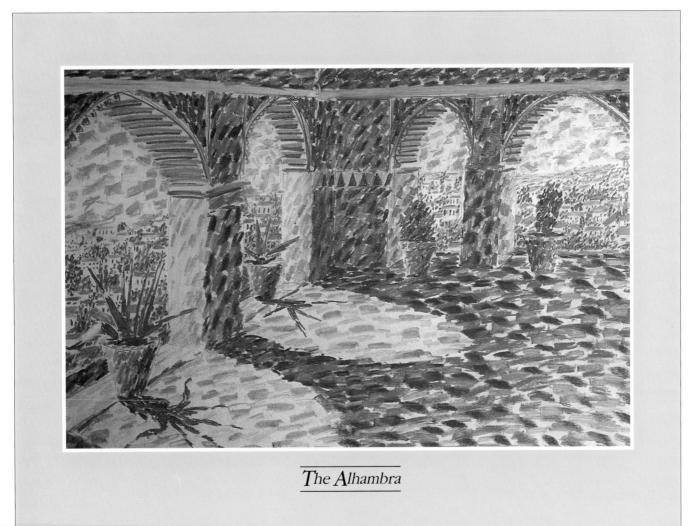

Using Mixed Media

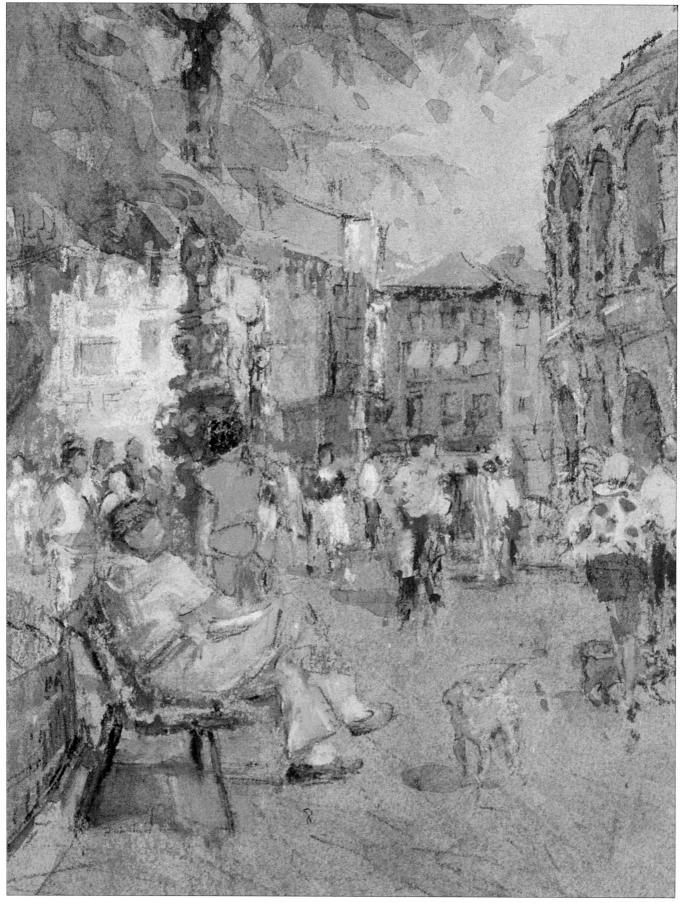

CHAPTER FOUR

USING MIXED MEDIA

Because pastel is such a flexible medium it can be combined successfully with other media to create optical and textural effects which will broaden the range and expressiveness of your paintings.

Of course, there are purists who object to the very idea of using any other medium in combination with pastel, just as some watercolorists object to the use of body color – Chinese white or gouache. The argument against mixed media is that it is a compromise solution – a crutch for the lazy artist who doesn't know how to exploit the full potential of pastel.

Others, however, might argue that this is like saying musical instruments should never be used to complement the sound of a singer's voice. Personally, I see nothing wrong in combining two or more media that have a natural affinity and that complement each other – so long as it is done for a purpose and not just to be clever or slick.

> This study by Diana Armfield, *People in Piazza Bra, Verona*, combines watercolor and pastel so skillfully that the media appear to blend into one another with no obvious difference in either color or texture. Light washes of watercolor have been used on the tree and parts of the buildings, while in the foreground pastel has been applied very lightly, with quite large areas of the gray-blue paper left uncovered to provide the neutral middle tones.

The master pastelist, Degas, was always experimenting with the medium, and one of his favorite techniques was to turn his pastels into a kind of distemper paste by spraying warm water over them. He then set about working into the wet paste with stiff brushes and varied the textures of the pastel from a thin wash to a thick impasto.

ing Mixed Media

In a mixed-media painting you can exploit the unique qualities of each medium and use them to enhance each other; the flowing, washlike qualities of paint make a perfect foil for the crisp lines, the velvety, blended areas and the scumbled textures of pastel. When the ground color is allowed to shine through in places it creates striking optical effects with the pastel overpainting, particularly when contrasting colors are used. For example, try applying side strokes of blue pastel lightly on rough paper which has been toned with yellow gouache; the tooth of the paper breaks up the pastel strokes, allowing tiny speckles of yellow to strike through the blue to produce a luminous, optical green.

Aside from the aesthetic considerations, there are also practical advantages to using mixed media. For example, the tooth of the paper fills up very quickly when you're working on a complex subject with many layers of color, and this can make the work begin to look dense, tired and lacking in textural variety. A way of solving this problem could be to block in the initial layers of color with thin washes of paint and work on top of them when the paint is dry. This allows you to cover large areas quickly, while still leaving enough tooth for the subsequent layers of pastel to adhere to. Thus you avoid an overworked appearance by building up a lot of color with fewer layers of pastel.

You can also use thin washes of paint to establish compositions and broad color areas in the initial stages. This leaves you free to concentrate on color and texture in the pastel overpainting, without having to worry about whether the composition is working or not.

Pastel can be used on top of most painting media, except those with an oily surface. It also works beautifully alongside strokes of Carb-Othello pencils, which have a similar velvety texture.

When using water-based media with pastel, it is best to work on a pastel board or pre-stretched paper to avoid buckling.

PASTEL WITH WATERCOLOR

Delicate effects can be created by toning watercolor paper with a dilute wash of watercolor prior to the application of pastel strokes. Because watercolor is transparent, the white of the paper glows softly through the wash, lending a special luminosity to the color. Always allow the paper to dry thoroughly before working over it with pastel strokes. When using watercolor paper, be careful to choose a rough or semi-rough (Cold Pressed) surface with plenty of tooth to hold the pastel particles. Smooth (Hot-Pressed) papers are not suitable unless your design is to be an open, linear one. Remember also to

Pastel and watercolor can be combined in a number of ways. *Right* soft pastel has been applied lightly to watercolor paper with a rough surface. A watercolor wash is now laid on top so that the speckly marks made by the pastel show through the transparent paint.

stretch the paper before applying the wash, to prevent it from buckling.

Pastel can also be worked into a watercolor wash while it is still wet, or just damp. The granules of the pastel spread in the moisture, creating interesting textural effects. Alternatively, you can block in your design with soft pastel, using broad side strokes, and then work over the design with watercolor and a soft brush. The pigment spreads in the watercolor, creating a washlike consistency with an attractive granular texture. When dry, this pastel/watercolor mixture can be further worked over with pastel strokes.

Watercolor can also be used on tinted grounds, if you wish to modify the color of the ground without entirely obliterating it. Or you may wish to lay in the main areas of the composition with watercolor, providing a useful base to work over with pastel.

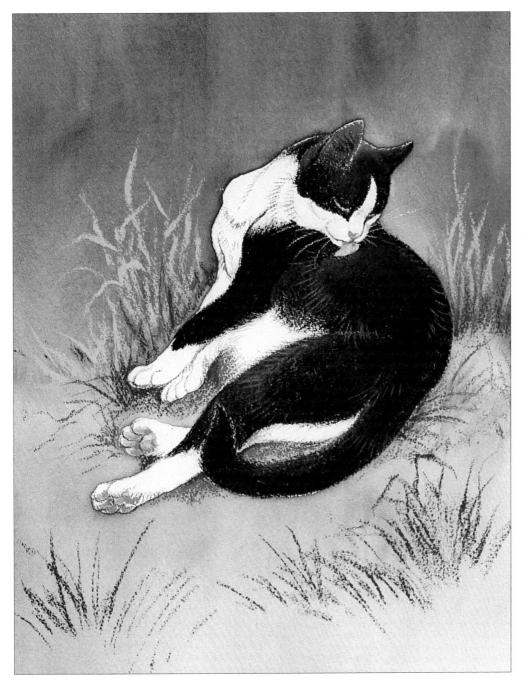

In this painting *left* of the artist's cat, watercolor was used for the background. A loose wash was laid on dampened, pre-stretched watercolor paper, which enabled a relatively large area to be covered much more quickly than would be possible with pastel. It has also created an interesting contrast in textures, with the fur of the cat conveyed by the thick build-up of pastel on the grainy surface.

PASTEL WITH ACRYLIC AND GOUACHE

Mixed Media

Since pastel is essentially an opaque medium, it combines most successfully with other opaque media. Acrylic and gouache are both opaque, and come under the category of body colors, i.e. waterbased media which have been made opaque by the addition of white pigment. Because of their covering power and fast-drying properties, they provide an excellent base for pastel work, either as a means of tinting the paper or as a part of the overall design of the picture. Because these painting media dry to a non-soluble finish, they won't intermix with the subsequent layers of pastel, so the pastel colors stay fresh and untainted.

The technique called *sgraffito* involves scraping away parts of a top layer of color to reveal either the paper or another layer of color below. Here a top layer of oil pastel is being laid over soft pastel.

Acrylic paints comprise pigment particles bound in a synthetic resin, and they can be diluted with water or acrylic medium to a thin consistency. They are extremely permanent and dry very quickly to an even, matte finish without changing in tone or color. **Gouache** is basically watercolor which has been made opaque by the addition of white pigment. Its opacity and covering power make it much more effective on a tinted ground than watercolor is. Gouache dries to a slightly chalky finish, which is particularly compatible with the grainy texture of pastel. Like watercolor, it becomes lighter when dry, and tends to dry rather patchily.

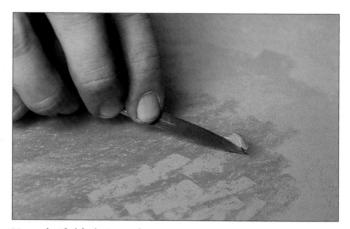

Now a knife blade is used to scrape away some of the oil pastel to reveal the other color.

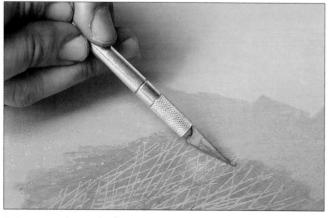

Scraping with a scalpel gives a much finer line, but care must be taken not to spoil the surface of the paper.

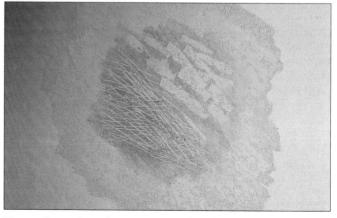

The marks made in this way can be extremely varied, and the color range can be increased by applying further layers and scratching into either the one below or a lower layer.

OIL PASTEL WITH TURPENTINE

Oil pastels are pleasant to work with, but the technique of using them is different to that of ordinary pastels, and they come in a much more limited color range. To some extent they can be mixed on the paper, but if used by themselves they tend to clog if overworked. If you use them with a turpentine or mineral spirit wash, however, they can be thinned and manipulated to create a tremendous variety of textures and color effects.

This technique works best if the oil pastel is applied quite heavily with broad side strokes. Work into the pastel with turpentine and a clean, soft brush; as the pastel mixes with the turpentine it takes on the quality of watercolor or thinned oil paint. The color also turns richer and darker, and remains so even when dry. You can then work over the painted design with linear strokes of oil pastel to add textural variety. Cotton balls or cotton buds can be used for blending small areas of color, and corrections made by wiping out parts of a painting with a rag soaked in turpentine.

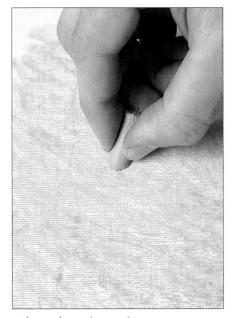

Oil pastels can be used in a very painterly way by using turpentine (or white spirit) as a medium. This dissolves the pastel so that it can be spread and blended. Here oil pastel is being applied to oil-sketching paper.

Now a brush soaked in turpentine is used to push the pastel about the surface in a loose, scumbling motion.

Finally, more oil pastel is applied on top. It is not possible to produce flat, watercolor-type washes in this way, but it can be very effective for certain effects, and allows several layers to be applied over one another.

Churchyard

SOFT PASTELS AND WATERCOLORS ON WATERCOLOR PAPER

Watercolor and pastel can be combined very successfully, but it is vital to use a support which is suitable for both. Here watercolor paper has been used, prestretched to prevent it buckling when wet.

The artist began with an accurate outline drawing, particularly important in this case because he had to be sure of the placing of the watercolor washes. He then blocked in the sky rapidly with soft pastel, scumbling over it with a broad brush dipped in water, and adding some white while still wet. The green foreground was put in next with pastel, so that the two areas of bright color provided a key against which to place the more neutral color of the church.

The contrast between the different textures of the pastel and the watercolor gives the painting a lively and interesting surface, but texture has not been allowed to become too important, as this could have detracted from the atmosphere of quiet harmony.

1 When composing the picture, the artist has simplified the scene, choosing to omit the buildings on the right seen in the photograph *left* and taking the line of green horizontally across below the church.

2 The artist started this block of sky by hastily scratching in the area with soft pastel. Now, to give the impression of a haze of blue, he washes the

area with water, scumbling in the grains of the pastel with a brush.

3 While the sky is still wet, he works in some white texture, using the flat side of a white paillard pastel.

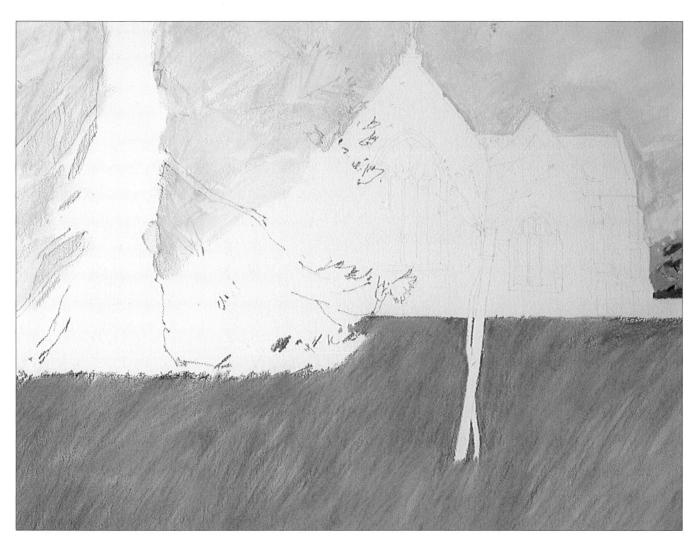

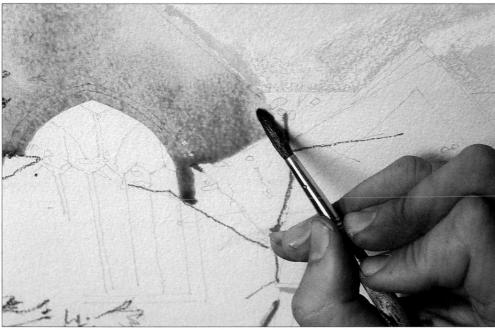

4 Matching diagonal strokes of mineral green and lime have been used *above* to give the foreground a grass-like texture and appearance.

5 The church *left* is painted in with watercolors used in the traditional wash method. Raw umber and black are the colors chosen, because the artist wants them to provide a pleasing contrast to the bright green pastels used for the grass. **6** The artist has spotted in the occasional daisy with soft pastels, fixing them with a fixative spray as he works to avoid them smudging.

ng Mixed Media

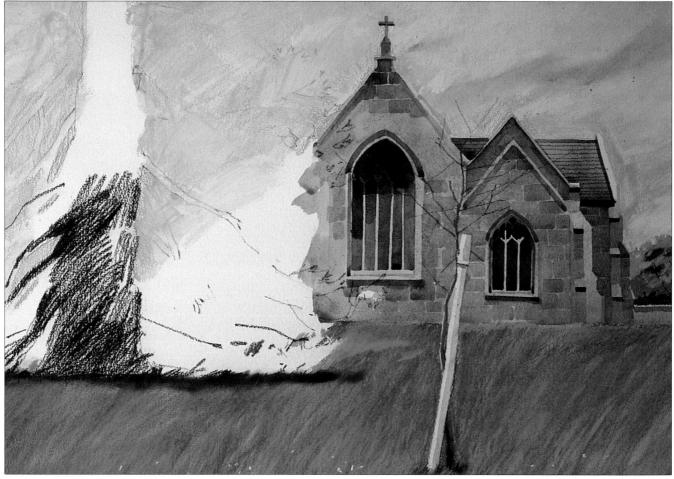

7 The tree is drawn in roughly in black crayon over the watercolor, and this is continued through into the border. Already some interesting textural contrasts are appearing: the softness of the watercolor helps to separate the solid mass of the church from the foreground and sky.

8 The artist has added a black wash to the tree, working over the black crayon, and now *left* he touches in the patches of sky between the branches with a soft blue pastel. **9** The final effect *below* shows how well watercolor can be combined with pastel. Notice how the artist hasn't made the large tree too densely black, and by adding touches of flesh-pink pastel to the small tree he has brought it forward toward the front of the picture. Details, like the tiles on the roof of the church and the twigs of the small tree, have been picked out in black conté pastel pencil.

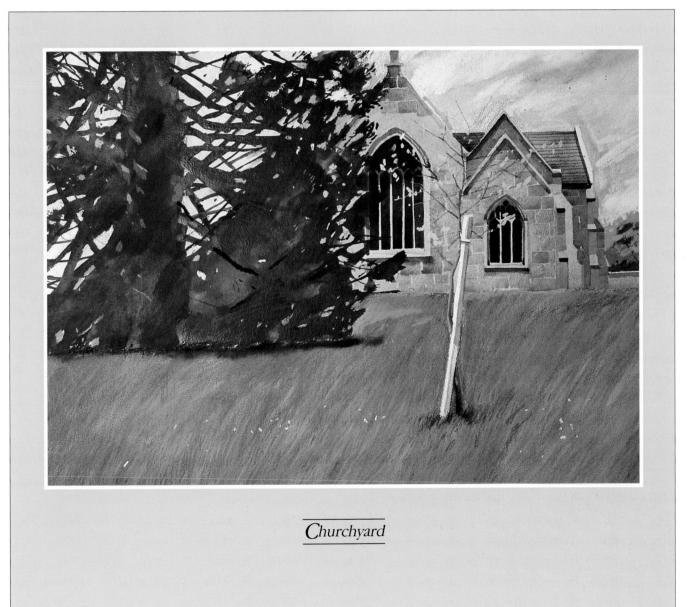

Composing the Picture

CHAPTER FIVE

COMPOSING THE PICTURE

Composition in drawing and painting is a fascinating and complex subject, and many books have been devoted solely to this one theme, describing the myriad principles that artists have evolved over the years for arriving at a successful result. However, I do feel that composition, like the use of color, should be largely a matter of observation, instinct and intuition. Frankly, the idea of composing a picture according to mathematical and geometric formulas leaves me completely cold. Composing a picture should be an organic process, rather than something to be carried out according to a rigid doctrine.

This is not to say, of course, that the design of a picture doesn't need careful planning – of course it does; all I'm saying is that you should trust your instincts and not allow yourself to be intimidated by the so called rules of composition. There is no such thing as a hard and fast rule in art – Edgar Degas broke every rule in the book and still managed to create stunning images.

In this chapter, then, I shall discuss composition in fairly simple terms, and offer some guidelines that I hope will act as springboards for your own ideas.

The initial impression this composition *left* gives is one of simplicity, but when you look closer, you notice that the elements which go toward creating such unity are in fact quite complex. It all hinges on an arrangement of colors and shapes to suggest depth and atmosphere. The sharply receding angle of the shutter helps lead the eye back to the sunlit market outside, while the green tone suggests a cool interior. PLANNING THE PICTURE

omposing the Picture

Not everything that you see in nature forms the perfect picture, a ready-made composition just waiting to be copied and set down on paper. No matter how breathtaking a view is, you may find that you have to select and re-arrange the elements of the scene in order to arrive at a satisfying pictorial design that continues to hold your interest beyond the first few moments of pleasure. If you simply set up your easel and plunge straight in to the painting, you will almost certainly live to regret it because the result will lack cohesion and look either bland and boring or confused and unbalanced.

Each time you approach a subject, then, start by making sketches and experiment with different viewpoints and arrangements of color and tone; try varying the scale of the elements and the relationships between them; and most important of all, decide what you want your picture to say and how best to emphasize what is most important about it.

UNITY AND DIVERSITY

The Greek philosopher, Plato, summed up the art of

composition most succinctly when he described it as creating "diversity within unity." By this he meant that a picture should have a satisfying wholeness and completeness, yet within it there should be a restrained and organized diversity of shapes and masses, rhythms, tones, colors and textures, to give life and interest to the picture. The artist must perform a kind of juggling act with all these elements and unite them so that they fit effectively within the picture space and are satisfying to look at.

The way to create unity in a picture is by introducing elements that relate to and echo each other, such as the similar shapes of trees, hills and clouds in a landscape, or the rounded forms of fruits, vegetables and jugs in a still life. These visual links have a pleasing effect, because the human eye finds related forms more satisfying than unrelated forms.

Tones (areas of light and dark) and colors will also create unity if they are kept within a fairly narrow scale and are connected subtly throughout the composition. Too many different colors and tones, arranged in a haphazard way, will have the opposite effect and leave the viewer feeling confused and

Here, the rhythm and movement of the sketchily drawn plants echo each other and give a strong sense of unity to much of the picture space. The liveliness of the line sets the mood of the picture, so it comes as something of a surprise to find greater coverage of color in the distance. The artist has chosen a high viewpoint which emphasizes this feeling of tension, but it is that very element of contrast which helps pull the picture together.

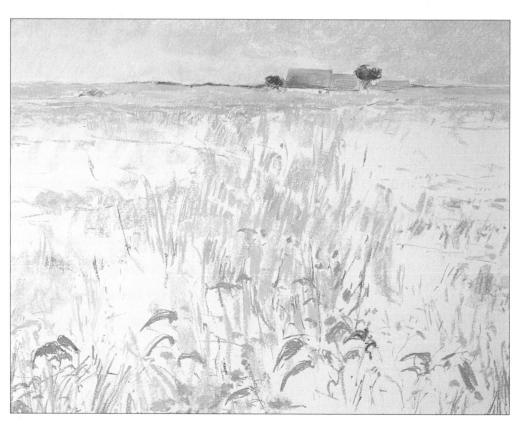

Repeated shapes, like these monoliths here, are much more interesting if you stress their lack of uniformity. The artist has paid particular attention to this, stressing it by varying the degree of shadow on each, and he has also chosen an off-center viewpoint which helps off-set the horizontal stretch of fields. Color too, has been used to enhance the shape contrasts, the intense yellow of the far-distant field effectively pushing the monoliths into sharp relief.

vaguely uncomfortable.

However, too much regular repetition has a "wallpaper" effect and makes for a monotonous picture. So it is necessary to think of ways to introduce diversity without detracting from the overall unity of the composition. For example, repeated shapes will be far more telling if they are not exactly alike, but vary slightly in size and outline. A line of trees which are all precisely equidistant will look like a row of soldiers; use a bit of artistic licence and vary the spacing between them. (Spaces themselves are an important part of a painting, and should be used in a positive way as shapes rather than just as areas where nothing happens.) In a landscape that consists of horizontals, introduce a vertical shape which acts as a counterpoint, or a curving line which leads the eye into the picture.

RHYTHM AND MOVEMENT

Closely connected with the idea of unity and diversity is that of rhythm and movement. Repeated shapes, tones and colors all set up visual rhythms that create a sense of movement and encourage the eye to travel through the composition.

Rhythm also sets the emotional tone of a picture; like musical rhythm, it can range from soft and soothing to lively and staccato. So, if you want to convey a calm, tranquil mood you might choose horizontal shapes, curving, rhythmic lines and closely related, harmonious colors and tones. For a dramatic mood, emphasize diagonal shapes and lines and introduce stronger tonal contrasts. A swirling, vortex-like rhythm, such as that used by J. M. W. Turner (1775–1851) in his stormy seascapes, creates a sense of turmoil and unrest. When planning a painting, think about shapes and rhythms and how they can be used to express what you want to convey in a painting; look for them in your landscape.

ARRANGING THE ELEMENTS

The way in which a picture is divided up makes an immediate impact; it is therefore important to think of the picture in terms of abstract shapes, colors and tones, regardless of what the subject matter is. Most pictures, for example, contain a focal point that is supported by other elements which lead the eye toward it, and these elements have to be carefully planned and placed.

Think of your paper as a stage and yourself as stage director in charge of the actors, scenery, props, and lighting. Imagine you are directing a dramatic scene: how will you arrange the lighting and scenery so as to gain maximum impact? How will you position the principal character and the supporting cast? THE FOCAL POINT

Composing the Picture

Most pictures contain one main center of interest – a point to which the viewer's eye is inevitably drawn. In answer to the question "does a picture need a focal point"? the nineteenth-century art critic John Ruskin replied "Indeed it does, just as a meal needs a main dish and a speech a main theme, just as a tune needs a note and man an aim in life."

A picture that has a main center of interest will communicate more forcefully than one that has not. But what if your subject contains several objects or areas that are potential focal points? You must determine, first of all, what your picture is about, or what you want to say in it, and then what to stress in order to say it. Stressing, or emphasizing, one element is partly a matter of subordinating the others. for instance by keeping a background less detailed and distinct or in a lower color key. This does not mean that these subordinate areas can be ill-drawn, but rather that the drawing should be firmly understood but not stressed. In a still life, you may wish to place emphasis on a jug of bright flowers and play down the other elements; in a landscape you can emphasize a dramatic sky by lowering the horizon line so that the land becomes less important by occupying less space; in a portrait, the sitter's face is generally the focus of attention, so you might deliberately tone down the colors and textures of the sitter's clothing, or treat them in broader and more sketchy terms.

The focal point can also be emphasized through tonal contrasts; placing the lightest light close to the darkest dark will immediately command attention by bringing the object forward to the front of the picture. You can also save the largest or strongest shapes and the most intense colors for the center of interest – it is all a question of selection and arrangement.

The positioning of the focal point needs careful consideration, too. Generally, it is placed somewhere near the center of the picture, because this is the point to which the viewer's eye is instinctively drawn. I say *near* the center advisedly, because a focal point placed in the absolute dead center will create identical spaces on either side of it, which can look boring and oversymmetrical. In pastel painting it is possible to concentrate solely on the main subject and omit the background altogether, in a technique known as "vignetting." The idea is to leave an area of the toned paper around the subject and gently fade out the edges with soft strokes that appear to melt into the surrounding paper. In order to achieve an integrated, harmonious result, it is important to leave areas of untouched paper within the subject as well as around it, for instance in a portrait the buff-colored paper can serve as the middle tone for the colors of the flesh. If the subject itself is too thoroughly "filled in" it will simply look as though you have forgotten to paint the background.

CHOOSING THE RIGHT FORMAT

As well as the compositional arrangement of the image itself, the shape and size of the paper or board should be considered carefully. With experience you will come to think of your subject simultaneously with the shape and size of area it is to occupy. For instance, as a general rule, a long, narrow rectangle seems to be the right shape for the broad sweep of a landscape or seascape. A square shape suggests stability, and may be suited to a still life or a close-up study of a single object. An upright format suggests strength and power, and is the usual choice for portraits. But does your view always have to conform to these rules? Might it not be as effective to place a rectangle on end to make it vertical, and thus create a more arresting view of a seascape?

Size is important also, and can have a strong effect on the way a person works, and therefore on the finished result. A large piece of paper may seem the right choice for a broad, atmospheric seascape, whereas a small one can be ideal for a still life or flower piece in bright, jewellike colors. But although it can be enjoyable to experiment with different shapes and sizes, a good compromise for beginners is to work with a reasonably sized sheet and start the painting or drawing well within it. This allows room to expand and develop the painting outward in any direction, and avoids constraints imposed by the proportions of the paper. In pastel painting it is possible to omit the background altogether so that attention focuses solely on the main subject. Unlike other media, the subject can be kept gently "locked" into the picture space by employing a technique called vignetting left. Here the soft strokes of blue picked up from the girl's dress, appear to melt and fade into the toned paper. Unity is achieved because the tone of the paper appears to reflect the flesh colors used in the girl's face.

Diagonals are an interesting way of guiding the eye gradually into the picture below, so that attention is diverted and arrested at various points without losing sight of the whole. Here, the verticals of this roofscape balance and complement each other so noticeably that we become interested in the shapes themselves, regardless of what they represent. Color emphasizes this interplay of lines, while at the same time giving sense to the subject matter.

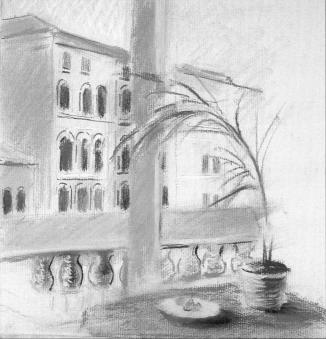

Set slightly off-center, the focal point *above* is the palm plant on its deep blue surface. But the very shape of the palm frond guides our eye to the buildings outside. These have an almost equal intensity of coloring to that of the interior, but we can read them as being outside because of the cool colors of the strong, vertical mullion.

Working with Color

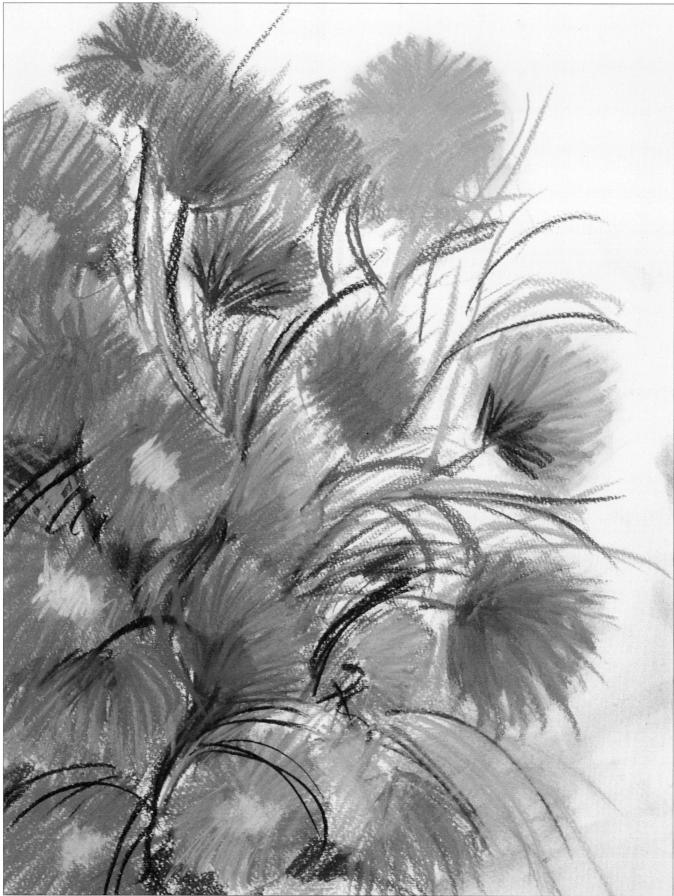

CHAPTER SIX

WORKING WITH COLOR

It is with some trepidation that I turn to the subject of handling color in pastel painting, because color is such a highly personal and subjective matter. It is difficult to talk about color in terms of rules and theories, or right and wrong; nevertheless it is important to have some understanding of how colors behave and how they relate to each other.

Color is also one of the painter's most potent means of expression, and you can use it to emphasize the mood of your painting, thus creating an emotional response in the mind of the viewer. For example, you can use contrasting or vibrant colors to create a strong, dramatic image, or soft, harmonious colors to create a subtle and evocative one.

The specific qualities of certain colors also evoke an emotional reaction. Colors such as red and orange are associated with warmth and sunshine, and generally create a positive response, whereas cool colors are more passive, associated with misty days and the cool of evening.

This chapter looks at how colors react together and at the many ways in which they can be used effectively in your pastel paintings.

> Soft pastels on white paper were used for this flower study, with the deep, bright colors gradually built up from a light blocking in. Tissue paper was used for blending in the early stages, and then the petals were drawn in rapid strokes of the pastel tip.

When considering the effects of color it is useful to know something about their individual properties and characteristics, and to understand what is meant by the various terms used to describe them.

THE COLOR WHEEL

orking with Color

The color wheel is a theoretical device which can be referred to when experimenting with colors and the ways in which they react with each other. It is really just a simplified version of the spectrum, bent into a circle. In the color wheel below, for example, you can see how those colors that are next to each other tend to harmonize, while colors on opposite sides of the wheel, called complementary colors, are sharply contrasting.

PRIMARY COLORS

Red, yellow and blue are known as the primary colors because they cannot be made by mixing other

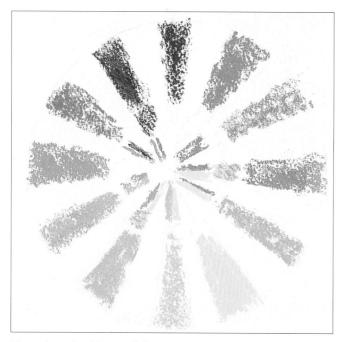

The color wheel is a useful device for working out how different combinations of colors can be used together to advantage.

colors – they simply exist. Theoretically, it is possible to mix every other color from the three primaries, but in reality this does not work – you cannot, for example, obtain a true violet by mixing a primary red and blue.

SECONDARY COLORS

When any two primary colors are mixed together, they form a secondary color. For example, blue + yellow = green, red + yellow = orange.

TERTIARY COLORS

These are made by mixing a primary and a secondary color. For example, red + orange = red-orange; yellow + green = yellow-green; blue + violet = blue-violet.

The following terms describe the specific properties that each color possesses, regardless of its position on the color wheel

Hue is simply another word for color, and refers to the generalized color of an object, as unaffected by light and shade. For example, when we say that grass is green we are referring to its overall hue, though the precise shade of green will appear lighter and warmer on a sunny day, darker and cooler on a dull day or in shadow.

Intensity refers to how bright a color is. Vivid, pure colors are strong in intensity; pale, grayed colors are weak in intensity. For example, lemon yellow, when applied thickly on a gray paper, appears intense and vibrant. If you then scumble a little blue of the same tone over it, the intensity of the yellow is lessened.

Tone, or value, refers to the relative lightness or darkness of a color, regardless of its hue or intensity. Colors can be graded on an imaginary tonal scale from white to black; light colors such as lemon yellow would appear white on the scale, whereas dark colors such as burnt umber would appear near the black end. If you look at a black and white photograph of a colorful scene, it is made up of a range of grays, with white and black as the lightest and darkest areas.

Temperature If you look at the color wheel, you will see that the red/orange/yellow half appears "warm" in relation to the other half, whereas the violet/blue/green half appears "cool." The reasons for this are partly scientific and partly psychological; we associate reds, oranges and yellows with the sun and firelight, and blues and greens with the coolness of grass and water. In addition, warm colors tend to "come forward," whereas cool colors appear to recede when placed near warm colors.

Within these broad categories, we find that each color group itself has varying degrees of warmth or

coolness. Thus, in the red group, cadmium red is warmer than alizarin crimson, which contains a percentage of cooling blue. Similarly, yellow ocher is a relatively warm yellow because it contains some red, whereas lemon yellow veers toward green and appears cooler.

Although the theory and its terminology needs to be understood, the really interesting part is learning how to apply it to the actual paintings. In the following sections, I shall explain how you can cleverly select and arrange particular colors to suit the end you have in sight, thus getting maximum expressive-

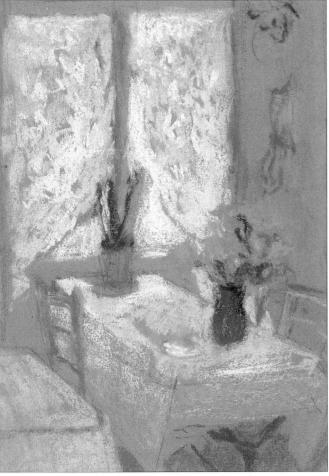

The effects of bright sunlight in an airy, well-lit room are conveyed beautifully here by the warm, glowing colors the artist has used. She has chosen a warm yellow-gray paper to work on, and has allowed it to show through in places, thus making links between the different parts of the picture. Notice how she has used bands of complementary colors blue and yellow — on the tablecloth to give a shimmering effect.

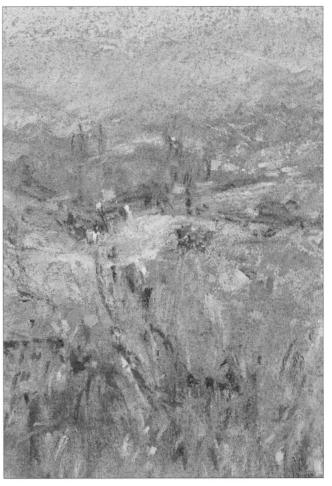

The effect of this pastel of a poppy field in France is charmingly spontaneous, but in fact the colors have been used both deliberately and cleverly to suggest space and recession as well as light and warmth. The red poppies, being the warmest color, advance to the front of the picture and dominate it, while the cooler, hazier blues and pinks of the hills recede into the distance, just as they do in nature. ness and maximum enjoyment out of your paintings.

HARMONIOUS COLORS

Any two or three colors which lie next to each other on the color wheel will appear harmonious – they work together well, with no jarring notes, since they share a common base color. Examples of harmonious color schemes might be blue, blue-green and blueviolet; or orange, red-orange and yellow-orange.

The most harmonious color schemes, of course, are to be found in nature. Think of the golds, russets and reds of fall, the subtle shades of blue and green you can see in the ocean, or the pinks, violets and indigos of the sky at twilight.

HARMONY AND MOOD

A picture painted with a limited range of harmonizing colors generally has a calm, restful appearance. There are no jarring color notes, just subtle changes from one hue to another, and this creates a unified, well-balanced image. Bear this in mind also when deciding what sort of mood you want to convey in your painting; for example, a portrait of a wistful young girl could be painted in harmonious colors to emphasize a feeling of quiet introspection, whereas a portrait of a child might be better suited to a more lively color composition. Similarly, harmonious colors in a landscape express a mood of calm and tranquillity.

In pastel painting, the color and tone of the paper can play a vital role in lending harmony and unity to a painting. When painting a seascape, for instance, I like to work on a blue-toned or gray-toned paper with loose pastel strokes that allow the paper to strike through and act as a unifying element that ties the other colors together.

There is a risk, of course, that too much harmony can make for a rather bland, insipid painting. One way to avoid this is to include a small area of contrasting color; for example a painting with a predominant theme of blue might benefit from a touch of a brighter color such as pink or yellow.

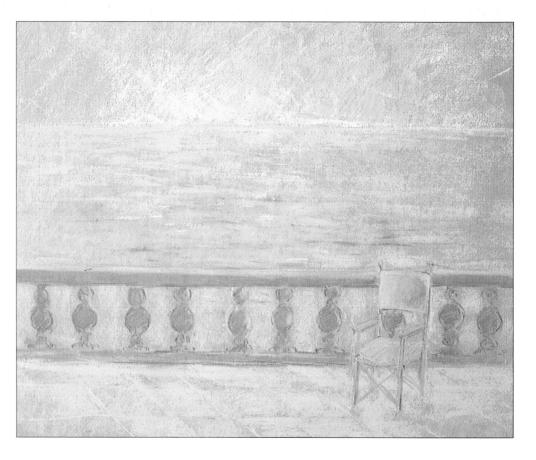

The range of pale colors here is very closely controlled, with each one blending almost imperceptibly into the one next to it. There is the minimum of contrast either in tone or in color. Harmonious colors do not necessarily have to be pale and delicate, as these are. They can equally well be dark or strong; the harmony comes from their close relationship on the color wheel.

Color, Tone and Mood

Earlier, I mentioned that certain colors are warm and appear to advance, whereas others are cool and appear to recede. Using these properties of projection and recession, it follows that you can use warm and cool colors to model form by emphasizing the projecting and receding planes of an object. Not only that, you can also create the illusion of threedimensional depth and space, particularly in landscapes. Once again, nature is your tutor in the use of warm and cool color; looking across a stretch of landscape, compare the cool, blue cast of trees in the distance with the warmer, more intense greens of those close to you. By capturing that color difference in a landscape painting, you will achieve a convincing sense of space and depth, because the eve perceives cool colors as being farther away than warm colors.

Warm and cool colors, because of their associations, can also be harnessed to help you express a particular mood. Warm colors suggest exuberance, optimism, passion and cheerfulness. Cool colors, on the other hand, suggest calm, restraint, aloofness, loneliness and sadness. Once again, these general rules shouldn't be taken as gospel – they are meant as starting points for your own ideas about color.

JUDGING TONAL VALUES

The ability to analyze the relative tones of a subject and match them in your painting is very important. Yet tone is a concept which gives many artists problems, amateurs and professionals alike. There is a much larger range of tones in life than in pastels – the tones around us range from 1–100 whereas those in paint range only from 1–40. You therefore have to make some tones equivalent in your painting. Just remember that tone doesn't refer to the color itself but to how light or dark it is in comparison to the colors surrounding it. The tone of a color cannot be assessed in isolation because it has no existence except in the context of other tones.

The best way to judge the tones of your subject is to look for a neutral middle tone – say, the gray of a sky or the soft green backcloth in a still life – and compare the rest of the tones to this to see if they appear darker or lighter. Keep your eyes moving all the time, from one tone to another and back again. If you still have difficulty in judging the relative tones, try the old trick of half-closing your eyes – this cuts out most of the color and extraneous detail, and reduces the scene to shapes of light and dark.

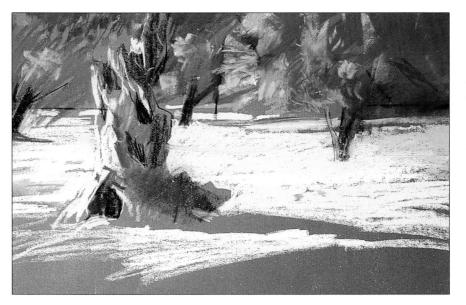

Unlike the atmospheric study opposite, this sketch makes dramatic use of tonal contrasts, or lights and darks. The subject was an olive grove in Crete, where the sun is strong and the shadows very distinct, and the artist has played up the contrasts by using complementary colors as well as tone. The dark blue paper has been used as the main shadow tone, while yellow, which is the complementary of blue, forms the light area of sunlit grass. Any two colors diagonally opposite each other on the color wheel are called complementaries. For example, blue is the complementary of orange, red of green and yellow of violet. The complementary of a secondary color such as red-orange is blue-green, and so on. Complementary colors need to be carefully controlled in order to be successful in a painting, but when used wisely they have great dramatic impact.

Vorking with Color

INTENSIFYING WITH COMPLEMENTARY COLORS

If two complementary colors of the same tone are placed near each other, they intensify each other by color contrast. Though you're not physically aware of it, the eye "jumps" rapidly from one color to the other, causing an optical vibration that makes the colors appear to shimmer.

However, if complementary colors are used in large amounts, and in equal proportions, the effect will be crude and garish. The secret is to create a web of small flecks of broken color, as the Impressionists did, so that the overall effect is harmonious.

Or you can use a small patch of a complementary color to counterbalance a large area of a particular color (notice how vibrant red poppies appear when growing in a green field, for example). Yet another method is to tone down both colors with their complementaries; for example, if you're painting a bowl of red apples against a green background, introduce flecks of green into the apples and flecks of red into the background – the colors will still intensify each other, but the overall effect will be more subdued.

NEUTRALIZING WITH COMPLEMENTARIES

When complementary colors are used next to each other, they intensify each other. Conversely, if they are mixed together they cancel each other out and form neutral grays and browns. For example, violet and yellow mixed together form gray, and red and green make brown. Depending on which colors are used, and the proportions of each, you can create a wide range of colorful neutrals – blue-grays, browngrays, red-browns, gray-browns, etc. Mixing all three primary colors together also produces a neutral gray. In the case of pastels, mixing will, of course, take the form of blending or scumbling, but the theory applies equally to pastels and paints.

However, a word about mixing and blending complementaries. On the whole, an optical mixture, that is one that mixes in the viewer's eye, appears more vibrant than a physically blended mixture. In other words, if you apply a layer of red and then scumble over it with green, you create a lively brown because the two colors each retain something of their identity and there is inherent movement within the color. The same applies if you use dots of color

Although the colors here are very muted, to suggest space and distance, complementaries — red and green — have been used in the foreground to bring the

poppies forward to the front of the picture. Without the splashes of red the picture would have lacked definition and interest.

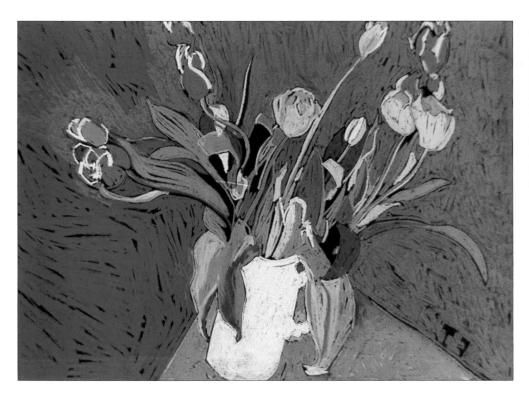

This bright flower piece provides an interesting contrast to the gentle landscape. Here the colors have been deliberately heightened, and two pairs of complementaries — red and green, and yellow and blue — are set against one another to create a vibrant color scheme.

next to each other, as the Pointillists did. Compare scumbled or dotted color to a flat, smoothly blended area of red and green and you'll see what I mean. Neutral colors don't have to be uninteresting – they should be subtle, but still lively; they are a necessary foil to more brilliant colors. The beauty of pastels is that since they cannot be pre-mixed, as paints are, you will achieve such effects without really trying.

MODIFYING WITH COMPLEMENTARIES

In oil painting, if a color looks too strident or too weak, you can easily alter it by wiping it off and overpainting. In pastel this is much less easy, because if you build up too many layers of color the painting begins to lose its freshness and vitality. This is where the principle of complementary colors once again comes in useful. For example, if you've painted a tree whose green looks too strident in hue, you can subdue it by scumbling or feathering over it with its complementary color – red. Thus the hue of the tree is modified rather than altered – and in fact it will probably be much improved anyway, because two colors working together are more lifelike than one color alone.

COMPLEMENTARY COLORS IN SHADOWS

To create a feeling of light and luminosity in your paintings, it is essential to notice the color in the shadows. If you look closely at a cast shadow, especially on a sunny day, you'll see that it may contain a touch of the complementary color of the object that is casting the shadow. So if you're painting a red vase, for example, try adding a little green to the color of the cast shadow; if the object is yellow, add a little blue-violet.

On the subject of colorful shadows, I am very fond of this little story about Eugène Delacroix (1798– 1863), the great nineteenth-century French painter. Delacroix was dissatisfied with the lack of emphasis in some yellow drapery he was painting. Deciding to go to the Louvre to see how Rubens had tackled the problem, he looked for a hackney cab. At that time, around 1830, the Paris cabs were painted canary yellow. When Delacroix spotted one, parked in the sun, he suddenly noticed the violet shadow underneath it. Fired with inspiration, he hastily paid the cabman and returned to his studio to paint violet shadows in the yellow drapery. The result? A masterpiece! Working with Color

Bowl of Cherries

CONTE OIL PASTELS AND PASTEL PENCILS ON WATERCOLOR PAPER

This bold, bright still life is a good example of working with a limited palette; the artist has used only a very few colors but has managed to make them say a good deal. Art teachers are fond of setting their pupils exercises such as using only the three primaries or no more than four colors, and these can provide an excellent discipline, as by limiting your color range you are forced to make decisions about composition or the placing of lights and darks which you might otherwise contrive to avoid.

The composition here is based on the juxtaposition of the reds and blues, with the two cherries on the table balancing those in the bowl. The reds, being warmer than the blue, assume more importance, but since the blue itself is a relatively warm one, the whole picture has a bright, cheerful look suitable to the subject.

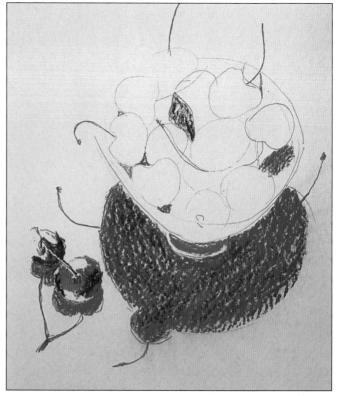

2 The green leaf could end up looking lost among so much intense coloring, so *above* the artist is sharpening it up by etching in the veins with a knife, a technique called *sgraffito*. **3** This detail *right* shows the range of reds, pinks, and purples the artist has used to build up the fruit, with the darker colors used to model them by suggesting the shadows.

1 There are lots of strong colors used here, so to stop them looking too flat, the artist has started to build up areas like the cherries. Here

she is working on the bowl. First she outlines it lightly in blue, and then she moves to the shadow area.

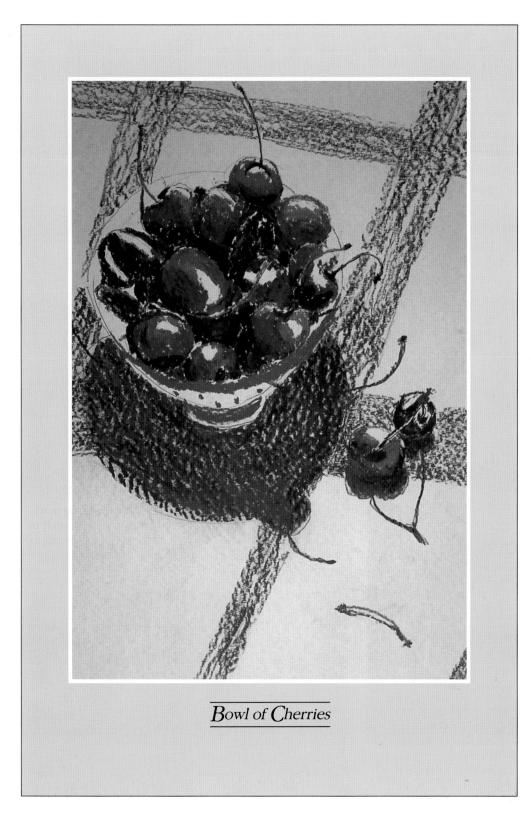

4 I like the way that turquoise helps define the fruit bowl so that the cherries don't dominate too much, and the artist has "pulled" that ultramarine away from the concentrated block of shadow to suggest the reflection from the window. As it's the same tone, it also gives unity to the picture, but being a cooler color than the red of the cherries it does not vie for attention.

View from a Window

HOME-MADE SOFT PASTELS AND CONTE PENCILS ON GRAY INGRES FABRIANO PAPER

In this painting, which is rather reminiscent of the Impressionists, the artist has used a variety of different strokes made with both soft and hard pastels to build up a lively evocation of sunlight and shadow. This is what is known as a "high-key" painting, in which the effect of lightness and gaiety is enhanced by the use of consistently light tones and colors, with the minimum of contrast. Texture is very important in a painting like this, and the artist has skillfully suggested different textures by using the pastels in a variety of ways. The diagonal hatching on the build-

orking with Color

ing breaks up what could have become too flat a surface, while the leaves of the tree have been built up quite thickly in contrast to the trunk, where paper has been left showing through to suggest the bark. Some details have been added in black conté pencil, but nowhere has the drawing been overworked, which might have destroyed the overall effect.

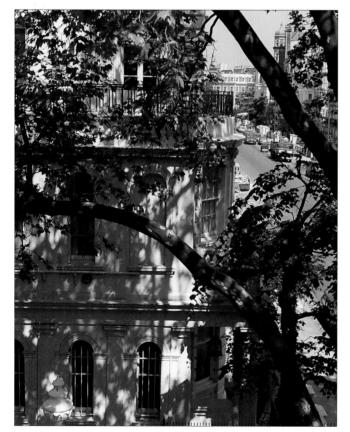

1 Notice how the artist has selected what interests him most about the scene, simplifying the rather confused pattern of light and shade seen in the photograph while still retaining the impression of light.

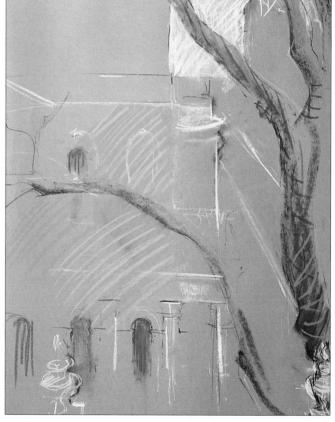

2 I like the artist's choice of support here. The paper has a gray tone which seems just right for showing up the white stucco of the building. He has started to define detail with white and dark gray conté pencils and the tree is lightly indicated in Indian red and Payne's gray. I feel the diagonal hatched strokes of Naples yellow were a good choice, and give a feeling of warmth to the building.

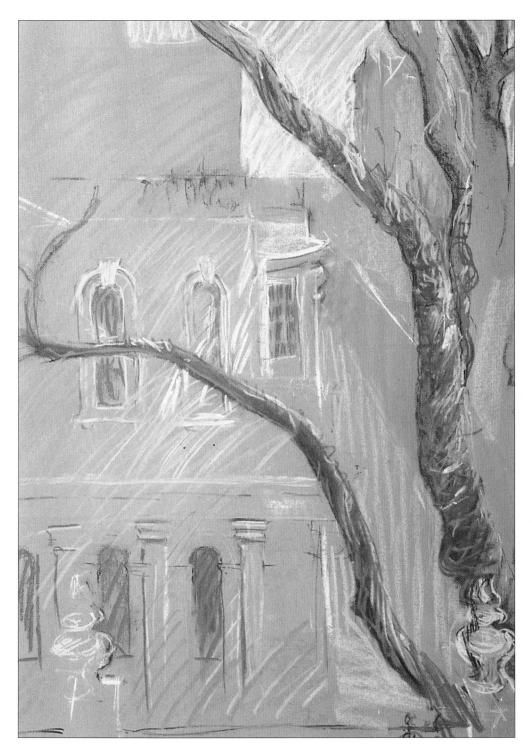

3 Here, light colors like primrose yellow and sap green have been used, to bring out the effect of dappled sunlight on the branches. The artist has mapped out the main shapes of the buildings and sky, and he has added a warm tone of Indian red to the road, the area behind the trees to the right of the building. This helps to bring the building itself forward by the use of a darker tone and, at the same time, adds more definition to the tree.

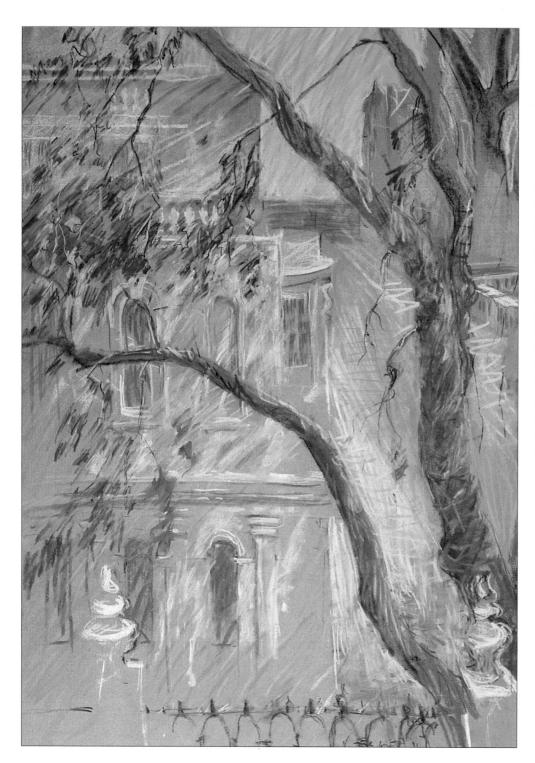

4 The colors of the road *left* are now built up in layers of Indian red, ultramarine, white and gray, while detail has been added to the tree in black conté pencil. I like the way the artist leaves plenty of the paper color showing through on the tree bark in contrast to the treatment of the leaves. These are put in on top of other layers of pastel, using a sharp range of greens to stand out against the cool cream of the building.

5 The whole scene *right* has been quite freely indicated to give the feeling of movement and dappled light. I like the way the artist hasn't overworked his colors and has made extensive use of drawing in color. Notice the way he has "bitten" in details with pencil – like the leaves and highlights on the treetrunk.

Working with Color

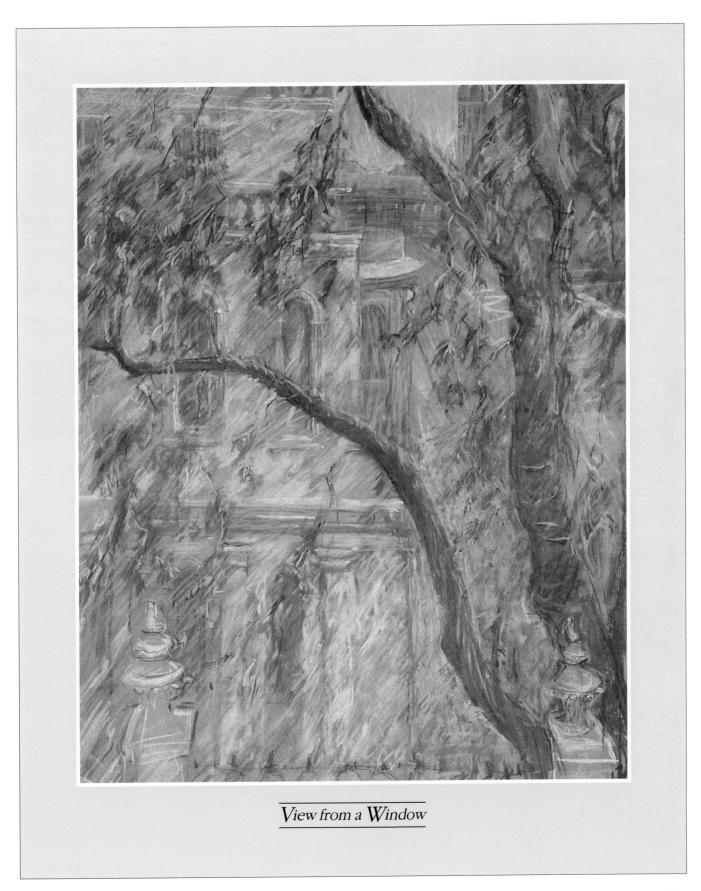

CHAPTER SEVEN

Mats And Frames

Because of their fragility, pastels must be framed under glass to insure against accidental smearing or tearing and to protect them from damp and dust. Once properly framed and sealed, however, a pastel painting is as permanent as a painting done in any other medium – and rather more so than a watercolor.

Unless you already have some experience of framing, this task is usually best left to a professional framer: it is a process which requires a degree of skill and considerable equipment. But whether you frame your own pastels or not, it is interesting and instructive to know something about the actual processes of framing, and there are certain aesthetic points to consider when choosing the style and color of a mat and frame. It is these which will be discussed in this chapter, not the actual techniques.

USING A WINDOW MAT

Mats and Frames

When framing a pastel painting under glass it is important that the painting does not come into contact with the glass, because this crushes the pastel particles and could cause smudging. The way to avoid this is to stand the pastel behind a window mat – a thick wide card "frame" within the actual wood or metal frame. A window mat serves the dual purpose of physically separating the painting from the glass and enhancing the appearance and content of the work. The mat, often but not always a delicate or neutral color, provides a kind of breathing space – a sympathetic surrounding that separates the image itself from the hard edge of the frame. Mats are available in various widths and thicknesses, and in materials that range from paper and card to fabrics such as silk and burlap. The width, color and texture of the mat will exert a considerable influence on the overall look of the painting so it is important to make a careful choice. If you are having your work matted professionally, the framemaker will show you made-up corners in different colors and textures. If you intend to cut your own, take your pastel with you when you choose a board. **Width** Traditionally, framers recommend that pastels are surrounded by a fairly wide mat and a narrow frame, since this arrangement enhances the airiness and delicacy of the work. However, this will

Traditionally pastels are surrounded by fairly wide mats and narrow frames, which enhances the delicacy of the work.

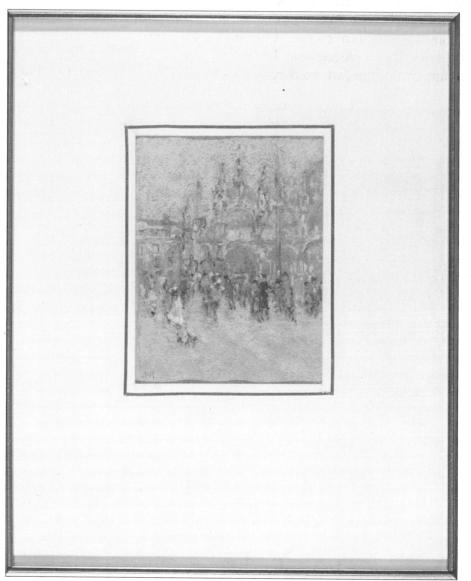

depend very much on the size of your painting; generally, the smaller the picture the wider the mat can be. A large painting with bold shapes and colors, for example, looks better with a narrow mat, or even no mat at all, whereas a tiny one can benefit by a mat which is actually larger than itself.

Color The color of the mat should never overpower the colors in the painting or make them appear washed out. If the mat color is, for example, lighter or brighter than the colors in the picture's center of interest, the two will vie for attention. In addition, it is worth taking into consideration the color scheme of the room in which the pastel is to be hung, if this is known. Pastels can also be framed without a mat, and this has become a fashion in the presentation of large-scale works. In this case, to prevent the glass from coming into contact with the pastel, small wooden frame inserts can be slipped inside the frame on all sides, where they won't show. Never show a prospective buyer an unmatted pastel. Presentation is always very important, and in my experience, unless your client is a dealer or fellow-artist, he or she will unconsciously think of unmatted works as "bits of paper" and tend to dismiss them.

CHOOSING A FRAME

The choice of frame is as important as the choice of mat, and ideally the two should be chosen together. When choosing a frame, you have to consider its width, color and design in relation to the picture itself. Like the window mat, it shouldn't attract too much attention to itself.

Width If your picture contains small, delicate objects or is surrounded by a large window mat, then choose a narrow frame. But if your picture is large and contains strong shapes and contrasting colors, it will look more imposing with a wide frame

It is often a good idea to set your pastel against a harmoniously toned double mat. This helps to balance the framed image and allows the eye to adjust to the greater width of the outer mat.

and no window mat, or a very narrow one.

Color The color of the frame should harmonize both with the colors in the painting and with the window mat. Generally, a color which is of a similar or slightly darker tone to the overall tone of the painting works best.

Design The character of the picture itself will determine whether it can take a heavy architrave molding, a simple flat molding or simply a ready-made metal frame. Personally, I dislike reverse slope moldings and find rounded or half-rounded moldings to be more sympathetic, but fashions in frames come and go, as they do in furniture and decor.

GLASS

There are two kinds of glass to choose from – ordinary and non-reflective. Of the two, I would recommend ordinary glass, even though it may cause annoying reflections under certain lighting conditions. Non-reflective glass is more expensive to buy, and tends to cast a matte sheen over the picture, which robs it of its freshness and textural beauty.

STORING PASTELS

Pastels should not be left unprotected for long, and should be stored in a safe place until such time as you can have them framed. Unmatted pastels should be separated from each other by a sheet of waxed paper, cellophane or tissue, and stored flat in a large drawer. A heavy board laid over them will protect them from any lateral movement and should press the grains of pastel more firmly into the paper, provided that the particles of unfixed pastel are tapped off before the picture is removed from the drawing board.

ats and Frames

and the board and then heated to fuse the two together. As pastels on paper are particularly vulnerable to

> However, mounting by either of these methods can be dangerous, and should only be done by a professional since there is a risk of spoiling the pastel. Most pastelists prefer to simply attach the paper to the back of the window mat with small pieces of tape as shown below.

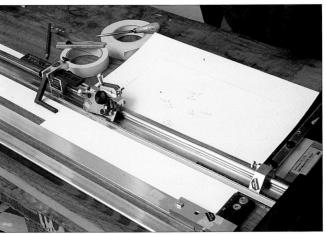

WINDOW MATTING VERSUS MOUNTING

accidental damage, they are sometimes given more

strength and stability by a process called mounting.

This involves sticking them to thick card or board, as

is frequently done with photographs. They can

either be wet mounted, by applying paste to the

back, or dry mounted, with special dry-mounting adhesive tissue which is placed between the pastel

1 When measuring up for a mat, establish the overall measurements first and trim the board to this size, then measure up for the height, depth and width, making

pencil marks on the back of the board only. Always allow a larger margin at the bottom than at the top or the picture will look unbalanced when it is hanging vertically.

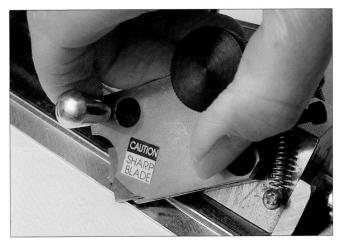

2 When choosing a matting board make sure that it is acid-free. Most good boards are, but ask your supplier if you are in any doubt. Here the mat is being cut with a

special matting device, available from art supply stores. Mats can also be cut with a sharp knife and a straight edge.

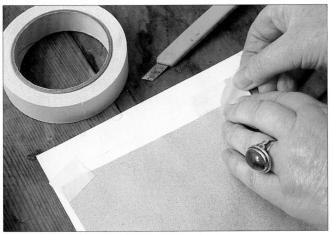

3 Light, delicate pastels are often enhanced by a wash line, an even band of color around the inner edge. An easier alternative is to make an indented line on the board

about 3/8 in from the inner edge. A burnishing tool is being used here, but any blunt-edged tool will create the same effect.

4 Pastels are usually attached to the back of the mat by small pieces of masking tape at the top only, the smaller the better as masking tape is not acid-free. This allows the

pastel to hang free so that any loose particles which become dislodged will fall down the back of the mat and not be visible.

Glossary

BLENDING Fusing colors together, with the fingers, a rag or a torchon.

BLOCKING IN Establishing the main forms and composition of a picture with areas of color and tone.

COMPLEMENTARY COLORS Those colors that are opposite each other in the color wheel, such as red and green, violet and yellow, orange and blue. Each one increases the intensity of the other when they are juxtaposed.

CROSS-HATCHING A technique of criss-crossing lines of color to create a fine mesh of color and tone.

FEATHERING The technique of making light, diagonal strokes over another color to lighten, darken or otherwise modify it.

FIXING Spraying a substance onto a pastel so that the color does not smudge or drop off the paper. Fixatives are varnishes sold in the form of aerosol cans or in a form to be applied by a mouth diffuser.

HATCHING A technique of creating areas of tone or color with fine, parallel strokes following one direction. HUE The term used for a pure color found on a scale ranging through the spectrum, that is red, orange, yellow, green, blue, indigo and violet.

IMPASTO A technique of applying pastel or paint thickly so that none of the support shows through.

OPTICAL MIXING The juxtaposition of blobs of colors so that the pigments do not actually mix, but at a certain distance they appear to do so.

OVERHAND STROKES Strokes applied with a pencil or pastel stick held between the thumb and forefinger. Holding the implement this way allows the artist to exercise the greatest control and accuracy over the marks made.

POINTILLISM A method of applying color in a series of dots rather than with strokes or in flat areas.

SCUMBLING Applying color loosely over another color to give an irregular, broken surface. SECONDARY COLORS The three colors formed by mixing pairs of primary colors; orange (red and yellow), green (yellow and blue) and purple (red and blue).

SGRAFFITO A technique of incizing into pastel or paint to create texture. Any type of mark can be created using any sharp instrument, from a pin to your fingernail.

STIPPLING Applying color by using little dots of color rather than flat areas or strokes.

SUPPORT The term applied to the material which provides the surface on which a painting or drawing is executed, for example, canvas, board or paper.

TEMPERATURE The term used to describe the relative "warmth" or "coolness" of a color. For instance, orange and red are warmer than blue and green.

TERTIARY COLORS Any color formed by mixing a primary with a secondary color.

TONE In painting and drawing, tone is the measure of light and dark as on a scale of gradations between black and white. Every color has an inherent tone, for example, yellow is light while Prussian blue is dark, but a colored object or surface is also modified by the light falling upon it and an assessment of the variation in tonal values may be crucial to the artist's ability to indicate the three-dimensional form of an object.

TOOTH A degree of texture or coarseness in a surface which allows painting or drawing material to adhere to the support.

TORCHON (OR TORTILLON) A stump of rolled paper used to blend colors.

UNDERHAND STROKES Strokes made with a pencil or pastel stick held in the palm of the hand and controlled by the thumb and fingers. The strokes produced are broad and sketchy and useful for covering large areas. Page numbers in *italic* refer to illustrations and captions

A

acrylic paints, with pastels, 100 The Alhambra, 102, 102-5 animals, 109 African Crowned Crane, 62, 62-5 Bullfinches, 76, 76-9 Elephant Running, 82, 82-7 *Goldcrests*, 54, 54-7 *Kitten*, 50, 50-3 The Racecourse, 58, 58-61 Raccoon, 92, 92-5 Ardizzone, Charlotte, 10 Armfield, Diana: Café at Ville-franche-le-Conflent, 15 People in Piazza Bra, Verona, 107 Aspidistra (Treanor), 14

B

backgrounds, 120, 121 binding agents, 18 birds: African Crowned Crane, 62, 62-5 Bullfinches, 76, 76-9 Goldcrests, 54, 54-7 blending, 38-42 bristle brush, 93 color gradations, 38, 38-9 creating depth, 42, 42 finger blending, 38, 55 mixed media, 111 mixing colors, 42, 42 modeling form, 40, 40 softening edges, 40, 41 The Blue Teapot (Leber), 10 boards: drawing, 28 matting, 141 pastel, 27, 54, 82 Bowl of Cherries, 130, 130-1 boxed sets, 20 bristle brush blending, 93 bristle brush erasers, 31 Bullfinches, 76, 76-9

С

Café at Villefranche-le-Conflent (Armfield), *15* charcoal paper, 26 charcoal pencils, 72 *Churchyard*, 112, *112-15* color, 8, 123-35

blending, 38-42 choosing, 19-20 color wheel, 124, 124 complementary, 128-9 composition, 118 cool, 20, 96, 125, 127 frames, 140 gradation, 38, 38-9 grading, 20-1 harmonious, 126 hue, 124 intensity, 124 mixing, 42, 42 mood, 126, 127 paper, 24, *37* primary, 124 secondary, 124 temperature, 125 tertiary, 124 tint charts, 21 tone, 21, 124, 127 warm, 20, 96, 125, 127 window mats, 139 complementary colors, 128-9 intensifying with, 128 modifying with, 129 neutralizing with, 128-9 in shadows, 129 composition, 117-22 arranging the elements, 119 focal point, 120, 121 format, 120 planning the picture, 118 rhythm and movement, 119 unit and diversity, 118-119 conté pencils, 54, 54, 80, 80, 92, 130, 132 cool colors, 20, 96, 125, 127 cross-hatching, 44, 44-5

D

Dawson, Doug, 503 Special, 12 Degas, Edgar, 7, 30, 108 Delacroix, Eugène, 129 depth, creating, 42, 42 diagonals, 121 drawing, 8, 62 drawing boards, 28 Dunstan, Bernard, Interior, Venice, 6

E

easels, 28 edges, softening, 40, 41 Elephant Running, 82, 82-7 equipment: drawing boards, 28 easels, 28 fixative, 29 work tables, 28 erasing, 28, 31 bristle brush erasers, 31 kneaded erasers, 31, 74 torchons, 31, 33, 52

F

Index

feathering, 43, 43 finger blending, 38, 55, 60 503 Special (Dawson), 12 fixatives, 29-31, 29 applying, 30-1 making, 31 flock velour paper, 50, 50-3 focal point, 120, 121 form, modeling, 40, 40 format, 120 fragility, 8, 18 frames, 137-41 choosing, 139 color, 140 design, 140

G

Goldcrests, 54, 54-7 gouache, with pastel, 110

Η

hard pastels, 18-19 color, 20 harmonious colors, 126 highlights, *56, 69, 70, 78, 97* hue, 124

Ι

intensity of color, 124 Interior, Venice (Dunstan), 6

K

Kitten, 50, *50-3* kneaded erasers, 31, 74

L

La Tour, Quentin de, 8 Landscape Near Castleton, 66, 66-71 landscapes, 125 Landscape Near Castleton, 66, 66-71 Summer Hedgerow, 48, 48-9 View from a Window, 132, 132-5 Leber, Deborah: *The Blue Teapot, 13 Waiting at Eastern Market, 10* light, *15* linear strokes, 34-5, *34-5* lost and found technique, *78*

M

making pastels, 22-3, 22-3 ingredients, 22 making sticks, 23 mixing the colors, 22-3 mats, 138-9, 138-9, 141, 141 color, 139 matting boards, 141 mistakes, erasing, 8, 28, 31, 31 mixed media, 107-15 modeling form, 40, 40 mood, 126, 127 mounting, 141 movement, composition, 119

N

neutral colors, 128-9 numbering, pastels, 21

0

oil pastels, 19 examples of use, 48 with turpentine, 111, *111* wet application, 19

P

paper, 24-7 charcoal paper, 26 colored, 25, 37 fine sandpaper, 26 paste boards, 27 rough, 24, 34, 37 smooth, 24, 35, 36 tone, 25-6 toning, 27 tooth, 19, 24 velour, 50, 50-1 washes, 27 watercolor, 26, 80, 80-1, 130 pastels: acrylic with, 110 boxed sets, 20 colors, 8, 19-20 correcting, 8 erasing, 28, 31, 31 fixing, 29-31 fragility, 8, 18 gouache with, 110 grading, 20-1 hard, 18-19, 20

Index

looking after, 21 making, 22-3, 22-3 manufacture, 18 numbering, 21 oil, 19, 48-50 pencils, 19, 76 sharpening, 18, 19 soft, 18 tint charts, 21 tonal range, 21 types, 18-19 unique qualities, 8 watercolor with, 107, 108-9, 108-9, 112, 112-15 pencils: conté, 54, *54*, 80, *80*, 92 pastel, 19, *7*6 People in Piazza Bra, Verona (Armfield), 107 photographs, as reference, 50, 58, 88 planning the picture, 118 pointillism, 47, 47, 102, *102-5* Portrait of Mrs Clark, 88, 88-91

Portrait of Natalie, 72, 72-5 portraits, 72, 72-5, 88, 88-91 primary colors, 124

R

Raccoon, 92, 92-5 The Racecourse, 58, 58-61 razor blades, 31, 31 repetition, composition, 119, 119 rhythm and movement, 119

rough paper, 24, *34, 37*

S

sandpaper, 26 sandpaper supports, 26, 48, 62, 66, 92 scumbling, 9, 46, 46 secondary colors, 124 sgraffito, 19, 110 shadows, 129 sharpening pastels, 18, 19 side strokes, 36, 36-7 size, composition, 120 sketches, 118 as references, 82, 82, 83 smooth paper, 24, 35, 36 soft pastels, 18 softening edges, 40, 41 sprays, fixative, 30-1 still life, 96, 96-101 Bowl of Cherries, 130, 130-1 Still Life with Fruit, 96, 96-101 stippling, 102, 102-5 strokes: linear, 34-5, 34-5 side, 36, 36-7 Study of the Artist's Hand, 80, 80-1 Summer Hedgerow, 48, 48-9 sunlight, 15, 125 supports see paper Swingler, Nick, 9

T

tables, 28 techniques, 33-47 blending, 38-42 color gradations, 38, *38-9*

creating depth, 42, 42 cross-hatching, 44, 44-5 feathering, 43, 43 linear strokes, 34-5, 34-5 mixed media, 107-15 mixing colors, 42, 42 modeling form, 40, 40 pointillism, 47, 47 scumbling, 9, 46, 46 side strokes, 36, 36-7 softening edges, 40, 41 stippling, 102, 102-5 tertiary colors, 124 tint charts, 21 tinted papers, 24-5, 27 tonal contrsts, 14 tonal range, pastels, 21 tone, 124 composition, 118 judging tonal values, 127 papers, 24-5 toning paper, 27 tooth, 24 mixed media and, 108 torchons, 31, 33, 52, 56, 78, 83, 94 Treanor, Frances, Aspidistra, 14 Turner, J.M.W., 119 turpentine, oil pastel with, 111, 111

U

unity and diversity, 118-19

V

Van Gogh, Vincent, 34 velour paper, 50, 50-3 View from a Window, 132, 132-5 viewpoints, 118 vignetting, 120, 121

W

Waiting at Eastern Market (Leber), *10* warm colors, 20, 96, 125, 127 washes, 27, 108, *109* watercolor, used with pastel, *107*, 108-9, *108-9*, 112, *112-15* watercolor paper, 26, 80, *80-1*, 130 wet application, 19 window mats, 138-9, *138-9*, 141, *141* color, 139 work tables, 28

Credits

Contributing artists

pp 48-9, 102-5, 130-1, Susan Alcantarilla; p 125, Charlotte Ardizzone; pp 15, 34-5, 40, 106, 124, 125, 128, 129, Diana Armfield; p 42, Christopher Assheton-Stones; pp 54-7, 62-5, 76-9, 80-1, 82-7, 92-5, John Barber; pp 132-5, Danny Chatto; p 12, Doug Dawson; p 6, Bernard Dunstan; p 122, Victoria Funk; pp 50-3, 58-61, 66-71, 88-91, Ken Jackson; p 121, Robyn King; pp 10, 13, Deborah Leber P.S.A.; p 109, Sally Michel; pp 72-5, 116, 120, 121, Guy Roddon; pp 45, 96-101, 112-15, Ian Sidaway; p 9, Nick Swingler; pp 14, 129 Frances Treanor.

Collectors

Doug Dawson's painting *503 Special* is in the collection of Mr and Mrs G. Slaughter; Deborah Leber's painting *Waiting at Eastern Market* is in the collection of Kathleen Sampek, and *The Blue Teapot* is in the collection of Victor Mitchell.

Quarto would like to thank all those who have helped in the preparation of this book, especially **Conté (UK) Ltd** and **Langford and Hill** for the loan of materials, **Diana Armfield** for allowing her pastels to appear in the book, and **Browse & Darby** for granting their permission to reproduce them.